A Study in African Socio-Political Philosophy

Ikechukwu Anthony KANU

authorHOUSE

AuthorHouse™ UK
1663 Liberty Drive
Bloomington, IN 47403 USA
www.authorhouse.co.uk
Phone: 0800.197.4150

© 2018 Ikechukwu Anthony KANU. All rights reserved.

No part of this book may be reproduced, stored in a retrieval system, or transmitted by any means without the written permission of the author.

Published by AuthorHouse 08/31/2018

ISBN: 978-1-5462-9744-4 (sc)
ISBN: 978-1-5462-9743-7 (e)

Print information available on the last page.

Any people depicted in stock imagery provided by Getty Images are models, and such images are being used for illustrative purposes only.
Certain stock imagery © Getty Images.

This book is printed on acid-free paper.

Because of the dynamic nature of the Internet, any web addresses or links contained in this book may have changed since publication and may no longer be valid. The views expressed in this work are solely those of the author and do not necessarily reflect the views of the publisher, and the publisher hereby disclaims any responsibility for them.

CONTENTS

Introduction ... vii
1. The 17Th Century Ethiopian Rationalists 1
2. Anton Wilhelm Amo ... 12
3. Edward Wilmot Blyden .. 19
4. Nnamdi Azikiwe .. 27
5. Leopold Senghor ... 39
6. Julius Nyerere .. 49
7. Obafemi Awolowo ... 66
8. Kwame Nkrumah .. 79
9. Frantz Fanon ... 90
10. Kenneth Buchizya Kaunda 103
11. Africa And The Actualization Of Millennium Development Goals .. 115
12. Slave Trade And The Socio-Political Economy Of Africa .. 142
13. Colonialism And The Socio-Political Economy Of Africa .. 164
14. Racism And The Socio-Political Economy Of Africa .. 177

INTRODUCTION

The issue of the history of African philosophy is one of the major concerns in the study of African philosophy. It comes with several questions such as: when did African philosophy begin? What should be included in the corpus of literature referred to as African philosophy? Referring to the ancient tradition of African philosophy, Hountondji (1976) argues that ethno-philosophy is no philosophy on the grounds of orature and the absence of dialectics. He further reasons that philosophy is a theoretical and systematic discipline motivated by a consciously dialectical discourse among individuals. He thinks:

> ... philosophy never stops; its very existence lies in the to and fro of free discussion, without which there is no philosophy. It is not a closed system but a closed history, a debate that goes from generation to generation, in which every thinker, every author, engages in total responsibility: I know I am responsible for what I say, for the theories I put forward....A philosophical... work.... is intelligible only as a moment in a debate that sustains and transcends it. (pp. 72-83).

He writes further:

> It always refers to antecedent positions, either to refute them or to confirm and enrich them. It takes on meaning only in relation to that history, in relation to the term of an ever changing debate in which the sole stable element is the constant reference to the one self-same object, to one sphere of experience, the characterization of which, incidentally, is itself part of the evolution. (pp. 72, 83).

Wirendu (1991), therefore, argues that there is a need to develop a tradition of philosophy in Africa which presupposes a minimum of organic relationships among its elements. Oguejiofor (2002) interprets Wirendu's perspective as including "...a sort of independence in the sense in which the existence of the results of a given thinker is dependent on the existence or the activities of his forebears in the philosophical enterprise" (p. 118).

The present work on "African Philosophy" brings in new freshness into the philosophical enterprise as it introduces not just thoughts that could be categorized as "African philosophy", but thoughts that were borne from the reflections of individual African philosophers. It covers a period that could be referred to as Modern African Philosophy. It includes philosophical activities in Africa between the 15th and early part of the 20th centuries. It is a collection of lectures delivered to my students at Saint Augustine's major Seminary, Jos and the Augustinian Institute, Makurdi.

THE 17ᵀᴴ CENTURY ETHIOPIAN RATIONALISTS

Introduction

What is today understood as Ethiopian philosophy emerged from the interaction of Greek pagan wisdom, early Patristic thought, Arabic philosophy and the African traditional pattern of thinking. It was written in Ge'ez language on the territory of the present-day Ethiopia and Eritrea. The Africanity of the Ethiopian philosophical system is manifest in her use of narratives, parables, and rich imagery preferred to the use of abstract argument as is evident in the Western philosophical enterprise. This pattern of thinking, far from abstract argumentation is again evident in the works of African philosophers like Iroegbu (1995; 2004) and Edeh (2007). Very significant to the 17th century Ethiopian Rationalists is their creative assimilation that fine-tunes Christian orthodoxy to the African traditional mode of thought; this has not been lost even in the present time, thus giving birth to an African-Christian synthesis.

This body of thought and its proponents are synthesized in the philosophical writings of Sumner (1974; 1976; 1978; 1985; 2004) on *The Book of the Wise Philosophers; The Treatise of Zara Yaecob and Walda Hewat; The Fisalgwos* and *The Life and Maxims of Skandes*. These constitute a major source as long as Ethiopian philosophy is concerned. However, during this period of doing philosophy in Ethiopia, two thinkers are significantly dominant: Zara Yacob and Wolde Hiwot, sometimes written as Zara Yaecob and Walda Heywat respectively. Their thought, in the contention of Asfaw (2004), is regarded as rationalistic because they believed that some knowledge about reality could be acquired through reason independent of sense experience, and more so, they were able to apply their own independent critical objection to the beliefs of the society. Expatiating further, Kelbessa (1994) states that:

> The 17^{th} century Ethiopian thinkers Zara Yacob and Wolde Hiwot, however, were not influenced by foreign culture. As we have stated earlier Zara Yacob reveals his ability and inclination to apply his own independent critical objection to the beliefs of his people. He was a critical independent thinker who guided his thoughts and judgments by the power of reason. The implication is that Ethiopians without foreign influence are not innocent of logical and critical inquiry. Of course; religious outlook exercised a profound influence on Zara Yacob's thought. That is why we label him as a rationalist philosopher in the religious Sense. (p. 449).

For the purpose of clarity and distinctiveness, we shall study the life and thoughts of Zara and Wolde differently.

1. Zara Yacob (1599-1692)

In the 17th century, under the influence of the Portuguese Jesuits, the conversion of King Susenyos of Ethiopia from Orthodoxy to Catholicism and his forceful attempt at imposing Catholicism on the Ethiopians, posed a challenge to the identity of the Ethiopian people. This attempt led to the emergence of the impressive independent thought of Zara Yacob. He was born in 1,500 AD from poor farmers in Askum. His thought pattern was profoundly theological, mastering both Coptic and Catholic theologies, with extensive knowledge of Jewish and Islamic religions.

He had a thorough traditional education in scripture, with more interest in the Psalms of David. With the unrest that emerged as a result of the conversion of King Susenyos, Zara took no sides and this attracted the anger of the King. He was denounced, and so fled to a secluded area in a cave near the Tekeze River. There, he reflected on the Psalms and the disagreements between religions, rejected all revealed religions and enthroned a rational faith. In 1632, Susenyos died and was succeeded by his son Fasiladas. His son brought the unrest to an end by affirming his commitment to orthodoxy. With this development, Zara returned and lived in Enfraz, where he dedicated his life to teaching and writing. He died in 1692.

Authority of Tradition

With his knowledge of the Christian and Jewish scriptures and the contradictions obtainable among religions, he rejected the authority of particular traditions, including the Ethiopian traditions under the belief that traditions are the product of human arrogance, leading men into the false belief that they know everything. The result of tradition is limitation of the powers of the human mind which has the ability of independent thinking. The mind is thus locked up in blind acceptance of ideas transmitted by their ancestors. He proposes a system of thinking, which is philosophical, whereby the unique authority to be accepted is reason, and other dimensions of knowledge, including scripture and dogmas be subjected to the court of reason. For him, not even the idea of God is beyond questioning. He writes:

> One day I said to myself in my own thought 'whom am I praying to or is there a God who listens to me?' At this thought I was invaded by dead full sadness and I said: 'In vain have I kept my own heart pure (as David says). Later on I thought of the words of the same David, 'Is the inventor of the ear unable to hear?' and I said: 'who is it that provided me with an ear to hear, who created me as a rational [being] and how have I come into this world? Where do I come from? Had I lived before the creator of the world, I would have known the beginning of my life and of the consciousness [of myself] that created me? Was I created by my own hands? But I didn't exist before I was created. (Sumner 1985, p. 233).

He writes further:

> If I say that my father and my mother created me, then I must search for the creator of my parents and of the parents of my parents until they arrive at the first who were not created as we [are] but who came into this world in some other way without being generated. For if they themselves have been created, I know nothing of their origin unless I say, 'he who created them from nothing must be an uncreated essence who is and will be for all centuries [to come] the Lord and Master of all things, without beginning or end, immutable, whose years cannot be numbered.' (Sumner 1985, p. 233).

Linking the creator with creation, he avers:

> And I said: 'Therefore, there is a creator; else there would have been no creation. This creator who endowed us with the gifts of intelligence and reason, cannot he himself be without them? For he created us as intelligent beings from the abundance of this intelligence and the same one being comprehends all, creates all, is almighty.' And I used to say: 'my creator will hear me if I pray to him,' and because of this thought I felt very happy. (Sumner 1985, p. 233).

Faith and Reason

As regards the interaction of faith and reason, he argues that they are inseparable, on the grounds that God is embodied in absolute reasonableness. To the question, faith and reason,

which is greater? He argues that faith can be greater if it has been examined by the court of reason.

Ethics

In his ethics, he maintains that God is a moral giver, but does not force human beings to follow his laws; he respects the freedom of men and women who through the light of reason can distinguish between good and evil. He wrote:

> God indeed has illuminated the heart of man with understanding by which he can see the good and evil, recognize the licit and illicit, distinguish truth from error, and by your light we see the light, oh Lord! If we use this light of our heart properly, it cannot deceive us, the purpose of this light, which our creator gave us, is to be saved by it, and not to be ruined [by it]. Everything that the light of our intelligence shows us comes from the source of truth. (Sumner 1985, p. 237).

Gender Inequality

In a world that relegated women to the background, Zara taught that men and women are equal, especially in a marriage relationship. He condemned the master-servant kind of relationship in marriage, and the teaching prevalent in his time, which extolled the monastic life over and above the married life; he maintained that it is false and cannot come from God (Belai, 1991).

2. Wolde Hiwot

During Zara's exile at Enfraz, where he engaged in teaching the children of the locals, Wolde Hiwot was one of the children he tutored. Wolde Hiwot was Zara's confidant; he encouraged Zara to write a short treatise which eventually became the first autobiography and philosophical work in Ethiopian history. As a disciple of Zara, Wolde systematized the ideas of his master, paying attention to the practical and educational problems of the time. The practicality of Wolde's philosophy, which addresses social and moral issues that were part of the daily experience of the Ethiopian mixed with the traditional thought of Ethiopians made his philosophy more Ethiopian than that of his master, Zara.

God's Existence

In his discourse on the existence of God, he began his proof like St Thomas Aquinas, starting with the things we see around us. He argues that all things were created, including ourselves, and since we are finite and cannot create ourselves, there must be a being who existed before all created things, without beginning and end, who created all things. Having asserted that God created all things, he goes on to maintain that all that God has created is good in its own way. Thus, our classification of some things as negative is as a result of our ignorance of the purpose of God's creation of them. Moreover, the human mind is imperfect and thus cannot understand everything (Asfaw, 2004).

Epistemology

In the human search for knowledge, Wolde gave priority to reasoning rather than faith. Like his master, he believed that faith must be rationally and critically analysed. Thus faith without reason as endorsed by some religions is not God's agenda, as it doesn't befit the nature of the rational creature (human beings) God has made. He further placed reason above emotion. Through reason, he argued that human beings can choose their actions. When we choose evil, God, who is perfect in his essence does not punish us because he is angry, we rather bring punishment upon ourselves through the commission of such an action. This is based on the idea that the choice of an action is the choice of the punishment due to the action.

Charity

He encouraged charity to the poor, especially those whose poverty is not born out of their laziness. He condemned thus, "He who lives on the work of another man while he has himself the capacity to work is a thief" (Sumner 1985, p.271). Through charity, God's blessings come upon us, for he made the rich and the poor, the weak and the strong to live together so as to support one another (Sumner, 1985). He further taught that parents have a great responsibility towards the training of their children. This obligation is both moral and religious. The example of the lives of parents, according to him cannot be underestimated as the children follow in their steps.

Gender Inequality

Wolde also addressed the issue of gender inequality. He avers that in marriage, man and woman become one and equal. He called for the mutual satisfaction of those in marriage, this includes conjugal acts so as to avoid adultery. He wrote:

> Draw near your wife marvelling at and praising your creator, and when you sleep with her, don't seek the pleasure of the conjugal act for you alone, but render it also pleasant for your wife and don't deprive her of the portion of pleasure that God gave her: therefore, don't be hasty, but act, so that her pleasure will not remain less than yours or be weakened. (Sumner, 1985, p. 278.)

Like Zara he avers that marriage is superior to the monastic life. He believes that the monastic life destroys the order instituted by the creator and is contrary to our nature. Of all the mysteries of nature, marriage for Wolde is the greatest.

Conclusion

Contrary to the popular Western belief of the 17th century that Africans cannot reason, and are still at the level of instinct, the philosophies of Zara and Wolde in 17th century Ethiopia have proved the otherwise. Hegel (1956) posits that the Negro is yet to go beyond his instinctual behaviour to identify a being outside of himself.

> In Negro life the characteristic point is the fact that consciousness had not yet attained to the realisation of any substantial existence.... Thus distinction between himself as an individual and the universality of his essential being, the African in the uniform, undeveloped oneness of his existence has not yet attained. (p. 93).

Contrary to this perspective, in Zara and Wolde, we find African independent thinkers doing philosophy and obeying the rules of logic and criticism. As a result of its written character and early development, it occupies an unrivalled place within the parameters of African Philosophy.

References

Asfaw, T. (2004). *The contribution of native Ethiopian philosophers, Zara Yacob and Wolde Hiwat, to Ethiopian philosophy.*

Hegel, G. W. F. (1956). *The philosophy of history.* New York: Dover.

Kelbessa, W. (1994). Foreign influence and its impact on Ethiopian philosophy. In H. G. Marcus (Ed.). *New Trend in Ethiopian Studies (pp. 440-449).* Lawrence Ville: Red Sea.

Sumner, C. (2004). The light and the shadow: Zara Yaecob and Walda Hewat. In Wirendu and Abraham (Eds.). *Two Ethiopian philosophers of the seventeenth century.* Ethiopia: Commercial.

Sumner, C. (1978). *Ethiopian philosophy, Vol. II. The treatise of Zara Yaecob and Walda Hewat.* Ethiopia: Commercial.

Sumner, C. (1976). *Ethiopian philosophy, Vol. III. The treatise of Zara Yaecob and Walda Hewat.* Ethiopia: Commercial.

Sumner, C. (1978). *Ethiopian philosophy, Vol. II. The treatise of Zara Yaecob and Walda Hewat.* Ethiopia: Commercial.

Sumner, C. (1976). *Ethiopian philosophy, Vol. 1. The Fisalgwos.* Ethiopia: Commercial.

Sumner, C. (1974). *Ethiopian philosophy, Vol. 1. The book of the wise philosophers.* Ethiopia: Commercial.

Sumner, C. (1974). *Ethiopian philosophy, Vol. 1. The life and maxims of Skandes.* Ethiopia: Commercial.

Pantaleon, I. (1995). *Metaphysics: The kpim of philosophy.* Owerri: IUP.

Pantaleon, I. (2004). Being as Belongingness: A Substantive Redefinition of Being. *In Ekpoma Review,* 1. 7.

Edeh, E. (1985). *Towards an Igbo metaphysics.* USA: Loyola University.

Belai, G. (1991). Ethiopian civilization. Addis Ababa: BSPE.

ANTON WILHELM AMO

(1703-1759)

Introduction

Anton Wilhelm Amo was the first recorded African philosopher or thinker to be active in Europe, the former German Democratic Republic. He was given birth to in Awukena, the coastal region of Axim in Ghana. He was transported to the Netherlands at the age of four and was given as a gift to Duke Anton Ulrich von Braunschweig-Wofenbuttel (1633– 1714), who in turn gave Amo to his son, August Wilhelm (1662–1731), who in 1708 christened him Anton Wilhelm. Makumba (2007) has two hypothesis on his coming to the Netherlands: one, that he was taken to the Netherlands by a preacher in Ghana for religious education to be a priest and a teacher; second, he was kidnapped by sea pirates, some records say the Dutch West Indian Company and taken to Europe as a slave. He was raised as a member of the duke's family and was given all the educational benefits thereof. It is believed that while at the palace, he must have met with Gottfried Leibniz who was a frequent visitor to the palace.

Between 1717 and 1721, he studied at the Ritter Academy of Wolfenbuttel. In the year 1727, he went to Halle University, where he studied Latin, Greek, Hebrew, French, and Dutch. He graduated from Halle with a degree in law in 1729. He continued his studies at the University of Wittenberg, where he focused on philosophy, history, and medicine, and earned his doctorate of philosophy in 1734. Amo subsequently taught philosophy, psychology and natural law at Halle Wittenberg where a statue has been erected in his honour and has been described as the Master Amo, who hails from Africa and more particularly from Guinea, and is a genuine Negro but a humble and honourable philosopher; a cursory glance at history reveals that he was the first African philosopher to teach in Europe. In 1938 he was made a professor, and in fact the first black professor in Germany. In Halle, he showed how patriotic he was of Africa by adding *Guinea-Afer* or *Guinea-Africanus* to his name. Although Hountondji (1983) avers that he made the additions to his name so that he and his circle will not forget his African origin and ties, it is very unlikely.

However, in 1740 Amo resigned from lecturing at Halle University and took up a post in philosophy at the University of Jena. It was during his days at the University of Jena that he experienced some unfavorable and unpleasant happenings in his life, namely: the Duke of Brunswick-Wolfenbüttel had died in 1735, leaving him without his long-standing sponsor and protector. Unfortunately, that happened at the same time when Germany was becoming intellectually and morally narrower and less liberal. Thus those who argued against the rights of Africans in Europe

were gaining grounds over those who campaigned for greater academic and social freedom. With the experience of racial abuses in Europe, he finally decided to return to Africa where Abraham (1964) avers that he lived like a hermit and acquired the reputation of a soothsayer. On his arrival in Ghana in about 1747, his father and sister were still alive. He probably died in about 1759 at Fort Chama in Ghana. Sephocle (1992) describes him thus:

> Amo is known as the black thinker, who, in spite of his exalted status, never came to feel quite at home in 18th century Europe. Consequently, in the later part of his life, he returned to his native Ghana, where he worked as a goldsmith. (p. 182).

He basically has two works: *Inaugural Dissertation on the Rights of Mores (Africans) in Europe (1726)* through which he fought against slavery and for the rights of Africans in Europe; *Dissertation on the Impassivity of the Human Mind (1734)* and *A Treatise on the Art of Philosophizing with Sobriety and Accuracy (1738)* a work he produced from his numerous lectures in Halle University, in which he developed an empiricist epistemology very close to but distinct from that of philosophers such as John Locke and David Hume. It is on the basis of these works that Nkrumah (1978), Hountonji (1983) and Osuagwu (1999) refer to him as an African philosopher.

Thoughts of Amo

Descartes, who had died in 1650 was a remarkable thinker and a towering figure in European philosophy and mathematics,

which perhaps, from my consideration, was one of the reasons why Amo decided to deal with his analysis of the mind and body in his *Dissertation on the Impassivity of the Human Mind (1734)*. First of all, he adopted the Cartesian Dualism arguing that the mind was distinct from the body because the body was sensory, changing and contingent; while the mind is linked to cogitation or thinking, which reveals the essential or necessary invisible feature of reality that are not sensible but comprehensible. While the body is destroyed after death, thinking continues. In thinking, we are linked to God who thinks reality in its clarity and distinctness. However, he criticized Descartes's dualism, the opposition between mind and body, which he found problematic. Amo did not reject the assumption that mind is a substance, but suggested, that there was inconsistency and confusion in Descartes' terms – how two fundamentally different substances can be in union. Taking an agnostic stand, Amo also argues, that "Although I do not know in what manner God and disembodied spirits understand themselves and their operations and external things, I do not think it probable that they do it through ideas." According to Amo, "it is the peculiarity of the human mind that it understands and acts through ideas, because it is very closely tied to the body." Nkrumah (1964) avers:

> The eighteenth-century African philosopher from Ghana, Anthony William Amo, who taught in the German Universities of Halle, and Wittenberg, pointed out in his *De Humanae Mentis Apatheia* that idealism was enmeshed in contradictions. The mind, he said, was conceived by idealism as a pure,

> active, unextended substance. Ideas, the alleged constituents of physical objects, were held to be only in the mind, and to be incapable of existence outside it. Amo's question here was how the ideas, largely those of physical objects, many of which were ideas of extension, could subsist in the mind; since physical objects were actually extended, if they were really ideas, some ideas must be actually extended. And if all ideas must be in the mind, it became hard to resist the conclusion that the mind itself was extended, in order to be a spatial receptacle for its extended ideas. (p. 64)

The mind thus must be living, and it could be so only by virtue of the body. Amo's critique of Descartes suggests that he may have been drawing upon an Akan understanding of the subject from his early years in what today is called Ghana. The metaphysics of the language so to speak, worked its way into his investigations of philosophy written in Latin. Wiredu (2004) analyses Descartes' interactionism of mind and body in categories that illustrates this point. The Akan would have a problem with the expression; I think, therefore, I am. He or she would ask: you are what? Where? Weridu explains: ``ho is the Akan rendition of exist. Without the`` ho``, which means ``there``, in other words, ``some place``, all meaning is lost. ``ho ``, standing alone does correspond to existential sense of the verb ``to be``, which has no place in Akan syntax or semantics.

In his piece on *Inaugural Dissertation on the Rights of Mores (Africans) in Europe (1726)*, Amo concerns himself with the rights of Africans in Europe. This Inaugural Dissertation,

which was directly related to his being an African, earned him candidature in both private and public law. He argues that African kings, like their European counterparts, had been vassals of Rome. By slave trade Europeans were violating the common heritage of Roman law, the principle that all the Roman citizens were free, including those who lived in Africa.

Evaluation and Conclusion

Smith (2013) reports that after Anton Wilhelm Amo defended a philosophy dissertation at the University of Halle in Saxony, written in Latin and entitled "On the Impassivity of the Human Mind," a dedicatory letter was appended from the rector of the University of Wittenberg, Johannes Gottfried Kraus, who praised "the natural genius" of Africa, its "appreciation for learning," and its "inestimable contribution to the knowledge of human affairs" and of "divine things" (p. 10). Kraus placed Amo in a lineage that includes many North African Latin authors of antiquity, such as Terence, Tertullian and St. Augustine. If this is so, then the racial prejudices of Hegel and Immanuel Kant are emotionally based. One of his greatest contributions to mankind and the black race in particular is fighting, through writing, the end of the deadly and unhonourable Trans-Atlantic Slave Trade. In fact, Grégoire (1808) describes him as one of "all those courageous men who have pleaded the cause of the unhappy Blacks and half-breeds, either through their writings or through their speeches in political assembles, and to societies established for the abolition of the slave trade, and the relief and liberation of slaves" (p. 120).

References

Abraham, W. (1964). The life and times of Anton Wilhelm Anon. *transactions of the Historical Society of Ghana. 7.* 60-81.

Gregoire, H. (1808). *On the Cultural Achievements of Negroes.* Amherst: University of Massachusetts Press.

Gordon, L. R. (2008). *An Introduction to Africana Philosophy*: New York: Cambridge University Press.

Hountondji, P. J. (1983). African philosophy: Myth and reality. London: Hutchinson University Library for Africa.

Makumba, M. M. (2007). *Introduction to African philosophy.* Nairobi: Paulines Publications Africa.

Nkrumah, K. (1978). Consciencism: Philosophy and ideology for de-colonisation. London: Panaf Books.

Osuagwu, I. M. (1999). A contemporary history of African philosophy. Owerri: Amamihe Publications.

Sephocle, M. (1992). Anton Wilhelm Amo. *Journal of Black Studies. 23. 3.* 182-187.

Smith, J. E. H. (2013). The enlightenments 'race' problems and ours. February. http://opinionator.blogs.nytimes.com/2013/02/10/why-has-race-survived/

Wiredu, K. A. (2004). *Companion to African philosophy.* Oxford: Blackwell Publishing.

EDWARD WILMOT BLYDEN

(1832-1912)

Introduction

Edward Wilmot Blyden, the versatile linguist, classist, theologian, historian, sociologist and philosopher was born on 3rd August, 1832 at West Indian Island of St Thomas of Denmark; he was born to free black parents, Romeo his father and Judith his mother, who were from the Igbo tribe of Southeastern Nigeria. He ranks as the first well known black thinker of black culture in the 20th century of the Christian era.

In 1845, Blyden met Rev. John P. Knox, a white American who was the pastor of St Thomas Protestant Dutch Reform Church. Growing up in the house of Knox, Eddy was mentored by Knox who encouraged his considerable aptitude for oratory and literature. As a result of his close association with Knox, the young Blyden decided to become a minister. He attempted enrolling into Rutgers Theological College, USA, Knox's *alma mater*, but was denied admission because of his colour and race. Efforts were made to enrol

him into two other institutions but all to no avail. This was an experience that would hardly leave Blyden. He was encouraged by Knox to go to Liberia or any other American colony. He went to the Free Republic of Liberia to work for the pan-negro ideal. Arriving only a few years after independence in 1851, Blyden taught at the Presbyterian Alexander High School. He taught himself Latin, Greek and Arabic and quickly became a public figure.

While in Liberia, he got married to Sarah Yates who was the niece of the Liberian Vice President, Hillary Yates. However, with the overthrow and murder of President Roye of Liberia, Blyden had to flee to Sierra Leone in 1871. In the capital of Sierra Leone, Freetown, he established and edited *The Negro* which was the first pan-African journal in West Africa, and undertook several government missions. Blyden died in Freetown practically penniless on 7th February, 1912 and was buried at the Race Course Cemetery.

Bearing in mind the European domination of Africa, Blyden's works and thoughts focused more on the ideas of race, race-pride, love of the fatherland (Africa), and belief in a brilliant African renaissance. This thought that every race is a natural unit, having its own "home" continent, characters, and mission, and to this simple fact he was considered a precursor of Negritude. As a writer, Blyden was regarded widely as the father of Pan-Africanism. He strived for the reunification of the blacks all over the world.

From 1855 – 1856, he edited the *Liberia Heral*. He also spent time visiting British colonies in West Africa, particularly

Nigeria and Sierra Leone, writing for newspapers in both colonies. While in Nigeria, he edited the *Lagos Weekly Record*. He maintained this with the America Colonization Society and published in their journal known as *Africa Depository and Colonial Journal*. As a diplomat he served as an ambassador for Liberia to Britain and France. During his vibrant days he served as the Liberian Secretary (1862-1864). He was later appointed Minister of the Interior (1880-1882). He taught in Classical Liberia College (1862 – 1871), He also served as its president (1880 – 1884) spearheading the college through a period of expansion. In 1885, Blyden unsuccessfully contested for the seat of President in Liberia. From 1901 – 1906 Blyden was involved in the education of Muslim youths with the objective of enhancing dialogue between Muslims and Christians in Sierra Leone (Abanuka, 2011). There are a couple of works attributed to him. They include: *A Voice From Bleeding Africa (1856); Liberia's Offering (1862); The Negro in Ancient History (1869); The West African University (1872); From West Africa to Palestine (1873); Christianity, Islam and the Negro Race (1887); The Jewish Question (1898); West Africa Before Europe (1905); and African Life and Customs (1908)*.

Blyden's African Personality

In response to the question, "who is an African?" Blyden (1974) developed the idea of *African Personality*. Blyden (1893) uses the concept first during a lecture he delivered in Freetown, Sierra Leone on 19th May, 1893, after which he employed it often to express the African reality of his time. According to Filesi (1971), the concept arose as a

reaction to racial prejudice from the West, with the goal of developing a political philosophy that would serve as a catalyst to constructive solidarity among Africans, and also as a guide of action. It was used to refer to the character of the Negro race just like Negritude. In fact, Negritude and African Personality have their source in the same complex historical and social factors that affected blacks. They are both interpretations of feelings that were already remarkably impressed on the consciousness of people, both within Africa and in diaspora. This explains why Senghor (1978) avers that Negritude is the French speaking perspective of the concept of African personality. He referred to them as two sides or currents of the one movement of the same feelings and ideas, but with different intellectual expressions.

Blyden (1974) begins by investigating the history of Negros and discovers that Blacks are the sons of Ham, one of the descendants of Noah in the book of Genesis (10). He asserts that Egypt and the pyramids were built by the descendants of Ham. He demonstrated, from Biblical and archeological scholarship that the ancestors of the blacks constructed the tower of Babel, originated alphabetic writing, astronomy, history, chronology, architecture, plastic art, sculpture, navigation, agriculture and textile industry. His purpose of going back to history is to show that the Negro in ancient history contributed to world's civilization, and that not all of this was lost to the slave trade and colonialism. He further asserts that even after the slave trade and colonialism Africans have continued to be creative as it is evident in the Vey people of the West Coast of Africa invention of syllabic alphabets. He further writes:

> Now are we to believe that such a people have been doomed, by the terms of any curse, to be the servants of servants, as upholders of negro slavery have taught? Would it not have been a singular theory that a people destined to servitude should begin, the very first thing, as we have endeavoured to show, to found great cities, organize kingdoms, and establish rule... (p. 414).

He however looks forward to the restoration of the ancient glory of the Negro. Blyden cited by Lynch (1970) exhorts Negros to:

> Betake themselves to their ancestral home, and assist in constructing a Christian African empire. For we believe as descendants of Ham had a share, as the most prominent actors on the scene, in the founding of cities and organization of government, so members of the same family, developed under different circumstances, will have an important part in the closing of the great drama.

Blyden (1974) believes that the black civilization was stolen by the whites, which systematically degraded the Negro by rewriting the history of human achievement and civilization to the disfavour of the Negro.

Not minding that the personality of Negro has been ravaged, he is optimistic that change is possible through the education of the Negro of his capabilities and contribution to ancient civilization. The kind of education he called for is one that should address issues that are prevalent in the

Negro's environment. Blyden (1967) avers that, "Lord Bacon says that 'reading makes a full man'; but the indiscriminate reading by the Negro of European literature has made him, in many instances, too full, or has rather destroyed his balance" (p. 81). The aim of negro education should be the formation of an African personality.

If there is anything unique about the African, it is not that he is cunning, slow, negligent and ruled by caprice as the white man has made him understand and as it is taught in Western schools, but that he led civilization. He does not intend to argue that the black man is the same with the white, except in dignity. He, thus, vehemently opposed racism. He argues that:

> There is no absolute or essential superiority on the one side, nor absolute or essential inferiority on the other side. It is a question of difference of endowments and difference of destiny. No amount of training or deficiency will make the Negro a European; on the other hand, no amount of training or deficiency of culture will make the European a Negro (p. 227).

He believes that there is no room for comparism as both races are moving on parallel lines. As regards the superiority of one race over another, he sees it as a pointless issue since all men and women are essentially equal. Because of the differences in endowment and destiny, he prefers to talk about complementarity instead of superiority. While Europe is gifted with science and industrial development, Africa is endowed with spiritual values. Both are necessary for

the development of a human being; thus the need for complementarity. Blyden (1908) further argues that one of the distinguishing characteristics of an African is his community organization of life anchored on the family; he argues further that polygamy is the foundation of African family. Added to this is the mystical character of the African society which flows from its religiosity. This religiosity, which includes the belief in a common father or God, further leads to hospitality. Blyden (1967) writes that, "The belief in a common creator and father of mankind is illustrated in the bearing we maintain towards our neighbour" (p. 115). This sense of hospitality towards the neighbour is shown even to strangers and foreigners.

Having noticed the shortcoming of white missionaries, Blyden (1893) became pessimistic of missionary activities in Africa. He placed Islam above Christianity on the grounds that Islam allows the African to be a master of his home, while in places where Christianity is present, foreigners take over the home of the African. He also observes that the negro is more badly treated in environments evangelized by Christian missionaries. However, he promoted the need for an African kind of Christianity; the translation of the Bible into African languages; and that black missionaries to fellow blacks will make a more profound impact, in terms of the Christianization of Africa and the Africanization of Christianity.

Conclusion

Abanuka, B. (2011) *A history of African philosophy*. Enugu: Snaap.

Filesi, T. (1971). *Movimenti di emancipazione colonial a nascita dei nuovi stati in Africa*. Milano.

Blyden, E. (1974). The Negro in ancient history. In M. S. Henry (Ed.). *The people of Africa: A series of papers on their character* (pp. 6-21). Ibadan: Ibadan University Press.

Lynch, H. R. (1970). *Edward Wilmot Blyden: Pan-Negro Patriot*. Oxford: Oxford University.

Blyden, E. W. (1893). Race and Study. Sierra Leone Times. 27th May.

Senghor, L. S. (1978). Selected letters of Edward Wilmot Blyden. H. R. Lynch (Ed.). New York: KTO.

Blyden, E. W. (1893). Christianity, Islam and the Negro race. Edinburgh: Edinburgh University.

Blyden, E. W. (1908). African life and customs. London: African Publications Society.

NNAMDI AZIKIWE

(1909-1999)

Introduction

During the 19th century, the scramble for territories by European powers took a new turn as they began to make significant advances to tropical Africa. By 1913, European powers had divided the African continent into a patchwork that showed little or no regard for ethnic and linguistic boundaries. This opened the African version of colonialism. The human and natural resources of Africa were exploited, independent African communities lost their political liberty, Africa suffered a crisis of 'self-confidence', creating a lasting sense of inferiority and subjugation that builds barrier to growth and innovation (Kanu, 2007). In the face of these exploitative and ideological devaluation of the black race, emerged an interesting package to the development of African political ideology.

Many Africans began the search for an ideological project of self-affirmation and assertive cultural nationalism (Makumba, 2007). Among these were Nnamdi Azikiwe, the

Pilot of Nigerian Independence, Leopold Senghor, appraised as an apostle of negritude, Kwame Nkrumah, a radical nationalist and a proponent of Pan-Africanism, Obafemi Awolowo, a socialist oriented nationalist, Julius Nyerere, the father of Ujamaa Socialism (Nwoko, 2006). This notwithstanding, this chapter is streamlined to attending to the political philosophy of Nnamdi Azikiwe.

The Man Nnamdi Azikiwe

Nnamdi Azikiwe, popularly known as Zik, was born on November 16, 1904 in Zungeru, Niger State into the family of Obededom Chukwuemeka Azikiwe and Racheal Chinwe Azikiwe. His father was a clerk, and his mother was a trader. Residing all over Nigeria enabled him know how to speak the three main Nigerian languages: Igbo, Hausa and Yoruba. He left for the United States in the late 1920s. While in the US, he attended Storer College in West Virginia for two years (1925-1927). He later left for Howard University, where he was for two years (1927-1929). In 1929, he entered Lincoln University. In 1930, he received his BA degree in Political Science. In the summer of 1930, he was admitted to Columbia University to read journalism. He obtained an MA degree in Religion and Philosophy at Lincoln University (1932). While still at Lincoln University, he was employed as a Graduate Assistant. In 1933, he concluded two Master's degree programs in Anthropology and Political Science at the University of Pennsylvania, where he was appointed a full-time lecturer in Political Science in 1933. While still pursuing his Master's at Columbia University, he registered for his PHD. After accomplishing his academic dreams,

he knew it was time to return to Africa and join in the fight to free the black race from the colonial administrators (Biography From Answers, 2011).

He returned to Nigeria in the mid-30s and got involved in politics, forming the NCNC party. He was actively involved in Nigeria's fight for independence. His dream was finally realized on October 1, 1960 when Nigeria became an independent nation and he was sworn in as her first indigenous Governor-General and Commander-in Chief of the Federation. In 1963, Nigeria became a republic, and he was then made the First President. He was forced out of office in 1966 by a deadly coup. He returned to politics in 1978, by founding the Nigerian Peoples Party (NPP). In 1979 and 1983 his bids for the presidency were unsuccessful. He retired from active politics until May 11, 1996 when he passed away at the University of Nigeria Teaching Hospital, Nsukka. He was buried on November 16, 1996, at his country home in Onitsha (Biography From Answers, 2011).

The Rise of Zikism

Zikism is a political philosophy or ideology designed by Nnamdi Azikiwe. It aimed at the decolonization of the minds of young Africans, in preparation for a battle against the old Africa, brainwashed by their colonial masters. At a time when the chiefs supported British hegemony and were used to fight the liberal intelligentsia of Africa, Zik developed his philosophy as a reformist ideology. He stressed that Africa could only be emancipated by those who believed in the concept of a renascent Africa. The realization of a new

Africa must not be through bloodshed or disorder. The spirit of cooperation, respect and honour for the old Africa must abound.

Zikism began when Zik returned to Nigeria in the mid-30s and formed the NCNC. There was a huge mobilization of people, which created a ground for national consciousness. For this consciousness to be sustained, the development of an ideology was inevitable. This ideology took into consideration the basic views of its believers. These believers were called 'agitators' by Zik. Since it was an ideology that spoke to their situation, the believers spread the ideology and organized people around it, thus transforming the ideology into a motivating instrument of action (Nzimiro, 1978).

The Five Canons of Zikism

In his political theory, Nnamdi Azikiwe, in 1943, enumerated five principles that are vital to the political emancipation of Africa. They were also referred to as the *Five Canons of Zikism*. His aim was to provide a foundational structure on which a free national political system was to be built (Nwoko, 2006).

1. **Spiritual Balance**: Spiritual balance in Zik's perspective, called for respect for the opinion of others. This would involve allowing others the right to state their opinion without denying one's right to state his or her opinion. This he referred to as the cultivation of the spirit of *tolerant scepticism* for the views of one's antagonists (Nzimiro, 1978).

2. **Social Regeneration**: Social regeneration calls for the Jettisoning of all forms of prejudice, be they racial, national, tribal, societal, political, ethical etc. This takes us back to Francis Bacon's Idols, which are prejudices; but while these prejudices in Francis Bacon impede the acquisition of knowledge (Njoku, 2003), in Zik, they impede the realization of political regeneration. Nnamdi Azikiwe makes this call because an African, no matter where he or she is born, is an African. He strongly believed that to postpone the breaking down of all forms of barriers of tribal prejudice, be they inter-tribal or intra-tribal, is to postpone the social unity of Africa (Nzimiro, 1978).

3. **Economic Determinism**: Zik sees economic self-sufficiency as the ultimate means to the redemption of Africa. No matter how educated Africans may be, as long as they lack economic self-sufficiency, they will fail to realise a stable society. He also pointed out that education for the African is useless, unless it is adapted to the African environment. Azikiwe (1961) had this idea, when he called for "a state of society where the mind is brought into harmony with matter... a psychological conception deeply rooted in a material environment" (p. 15); He further argues that "The usefulness of any concept, idea or theory, lies in its implications for the practical solutions to the problems of society. In this sense, pragmatism requires that man's efforts and intelligence should be geared towards the liberation

of man and the satisfaction of his needs in society" (p. 277); and so our education should be aimed at providing means of livelihood for Africans.

4. **Mental Emancipation**: the slave trade and colonization of Africa created a situation of the 'crisis of self-confidence' in the African, which has opened apertures for a lasting barrier to growth and innovation. Zik argues that there is no specific proof to sustain the idea of superiority or inferiority of any race, and for the African to cultivate an inferiority complex is to sign the death warrant of Africa's future. He calls for emancipation from the crisis of inferiority and assures the African that he had a glorious past and can design a more glorious future. Zik wants the African to follow Socrates' principle: *Gnothi seauton, (Man know yourself)*, and like a sleeping giant wake up from his slumber and harness his power for his own good and that of mankind (Ozimiro, 1978).

5. **Political Resurgence**: If the African cultivates a spiritual balance, he experiences social regeneration, cultivates and realizes economic self-sufficiency and mental emancipation, he or she certainly finds himself or herself in a state of political *Risorgimento* (renewal or rebirth). Azikiwe (1961) writes:

> Politics is a means to an end which is more glorious than the means through which this end must be attained. Socially, the end is

guarantee of social security, and a right to enjoy life, liberty and the pursuit of happiness, just as do other peoples. (pp. 24-26).

Once this is attained, a people can boast of a stable and reliable political system.

The Problem of Tribe

In Zik's study of the Nigerian nation, he describes it as having evolved from tribe to nation, tribe, in the sense of an endogamous group descended from the same ancestor, occupying a particular territory and possessing cultural, religious and linguistic homogeneity. In Nigeria, he observes that there are about 400 of such tribes who have united and formed a political union in the form of a federation (Azikiwe, 1961). Thus, Zik envisages a threat to national unity. He raises the all important question: will the new autonomous state endure? He agrees that tribalism is a reality, but does not object that even in the midst of tribalism, national unity can be a reality. How the reality of tribalism can be adapted to the unreality of national unity to make national unity a reality is one of the basic concerns of Zik. Azikiwe (1961) enumerates the solution, which he refers to as keys:

a. To discover the circumstances which can be superimposed on the natural chains of language and culture, which has linked the human beings who inhabit Nigeria to enable them develop a feeling of personal security and group preservation.
b. He proposes a federal system of government which will concede coexistence to all linguistic groups, on

the basis of equality, within a framework of political and constitutional warrantees. Such a federal system of government would protect individual freedom under the rule of law and thus preserve and sustain any linguistic group. By preserving the linguistic groups of Nigeria and conceding to them local autonomy of some satisfactory nature, an atmosphere for respect of their culture and traditions is created.

c. If loyalty to the nation must not be replaced by loyalty to the tribe, Zik calls for the revision of the Nigeria's Republican Constitution: first in relation to safeguarding people's fundamental human rights; secondly, providing citizens with adequate food, comfortable shelter and a minimum level of subsistence. In this case, rulers must discover the material needs of their people. Once there is a failure in this by rulers, Nigerians will harbour grievances about political, economic and social inequalities. This will increase loyalty to tribe and disloyalty to the nation.

d. An effective way to increase national unity is to concede to each region *de jure* equality and *de facto* inequality. By *de jure* equality, Zik speaks in the sense that every province and local authority in each region in the Federal Republic of Nigeria is legally equal with the federal government providing for each of them. By *de facto* Inequality, Zik means the acceptance of the fact that not all regions, provinces and local authorities are equal either in area, population, natural resources and financial means.

e. Again, Zik argues that political parties will have to cut across the artificial barriers of tribes and regions. National loyalty must supersede regional claims.

Zikism: An Ideology of Political Regeneration for Nigeria

The geographical area that is today known as Nigeria was, before the colonial invasion, inhabited by people of varied and often conflicting traditional ideologies, cultural dispositions, and socio-political and religious orientations. In their respective domain, they cherished what they shared together as a people. But with the advent of colonial powers and missionaries, the policy of divide and rule along religious, cultural and political lines was introduced. Nigeria was divided into north and south (Ezeanya, 2010). This division of North and South keeps reminding Nigerians that they are different. And today, nothing in Nigerian history captures her problem of national integration more graphically than the chequered fortune of the word *tribe* in her vocabulary. As Achebe (1985) would say, 'tribe has been one time accepted as a friend, rejected as an enemy at another, and finally smuggled through the backdoor as an accomplice' (p. 5). If Nigeria as a nation would move ahead, aligning with the ideology of Nnamdi Azikiwe is inevitable. Nigerians must discover the circumstances which can be superimposed on the natural chains of language and culture, the fundamental human rights of the Nigerian people must be protected. The true federal system of government need to be introduced and political parties must cut across tribes.

Azikiwe (1981) began his political philosophy with a critical examination of the credibility and workability of capitalism, socialism and welfarism. From his critical analysis, he envisions the possibility of making good out of the best of these three political systems to forge a new system for Nigeria. He calls it Neo-welfarism. This is defined by Azikiwe (1981) as:

> An economic system which blends the essential elements of capitalism, socialism and welfarism in a social economic matrix, influenced by indigenous Nigerian mores, to enable the state and the private sector to own and control the means of production, distribution and exchange, while simultaneously enabling the state to assume responsibility for the social services, in order to benefit the citizens according to their needs and officially-specified minimum standards, without prejudice to participation in any aspect of the social services by voluntary agencies. (p. x).

He saw it as an ideology re-oriented and truly Nigerian, manifesting the Nigerian qualities: democratic according to her institutions, welfarist in her economic background, altruistic in her sociological life and religiously animistic. This system of government is eclectic and pragmatic in the sense that it makes a beautiful synthesis of rationalism and empiricism, incorporating into itself the utilitarian and practical elements of capitalism, socialism and welfarism. At this juncture, it is good to state the primary objectives of Neo-welfarism:

1. to reform and renew the instruments of power according to the Nigerian political experience;

2. to insist on the rule of law;
3. to bring about a total restoration and reinforcement of the fundamental rights of all citizens according to the constitution;
4. to bring into reality, the universally accepted principles of the separation of power between the Executive, Legislative, and the judiciary;
5. to bring about the renewal of confidence in the integrity of government;
6. to bring about a sincere and reliable organisation and administration of public utilities, welfare services, education, agriculture, recreational facilities and entertainment;
7. to introduce an open door policy in importation and exportation of products, and
8. to introduce and sustain a taxation policy that would be in accord with a reasonable scale (Azikiwe, 1981).

Conclusion

This is not to say that the political philosophy of Azikiwe is without its problems. Just like every other political philosophy it has its weaknesses. However, having studied other political systems, putting the Nigerian situation into context, the author joins his voice with that of many other African political philosophers in proposing that Azikiwe's political ideology, which fecundates the positive and workable principles of capitalism, socialism and welfarism with the root principles native to Nigeria, is the one political system that can restore the basis for a genuine Nigerian socio-political life.

References

Achebe, C. (1985). *The trouble with Nigeria*. Taiwan: AI-united.

Azikiwe, N. (1981). *Ideology for Nigeria: Capitalism, socialism or welfarism*. Lagos: Macmillan.

Azikiwe, N. (1961). *Renascent Africa*. New York: Negro University Press.

Azikiwe, N. (1978). *From tribe to nation: The case of Nigeria*. Onigu Otite (Ed.). *Themes in African Social and Political Thought* (pp. 274-280). Malta: Fourth Dimension Publishers.

Biography from answers (2011). *Nnamdi Azikiwe*. Retrieved 20th March, 2011 from.

Kanu, I. A. (2007). The colonial legacy: The hidden history of Africa's present crisis. View Point Magazine. 6.7. 23.

Elias, T. O. (1954). *Towards Nationhood in Nigeria*. In Occasional Papers on Nigerian Affairs. London: Nigerian Society.

Ezeanya, O. (2010). *Tribe and Tongue in Nigeria*. Enugu: Professor's Press.

Makumba, M. (2007). *Introduction to African philosophy*. Kenya: Pauline.

Nwoko, M. (2006). *Basic world political theories*. F. O. C Njoku (Ed.). Enugu: SNAAP.

Njoku, F. O. C. (2003). *Empiricists and causation in law*. Enugu: SNAAP.

Ozimiro, I. (1978). Zikism and social thought in the Nigerian Pre-independence Period, 1944-1950. Onigu Otite (Ed.). *Themes in African Social and Political Thought* (pp. 281-301). Malta: Fourth Dimension Publishers.

LEOPOLD SENGHOR

(1906-2001)

His Life

Leopold Sedar Senghor was born on 9th October, 1906 in the city of Joal, Senegal (Collins, 1990). He began his studies in Senegal at the age of eight in the Ngasobil boarding school of the Fathers of the Holy Spirit. He enrolled into a seminary in Dakar in 1922, and later attended a secular institution after he was told that the religious life was not for him. When he had completed his Baccalaureate, he was awarded a scholarship to continue his studies in France.

Senghor graduated from the University of Paris. He was subsequently designated professor at the Universities of Tours and Paris. In 1939, he was enrolled as a French army. After a year, he was taken prisoner by Germany. He was to be executed with the others who were captured with him, but they escaped this fate. In total, Senghor spent two years in different prison camps where he spent most of his time writing poems. He was released in 1942 on medical grounds.

Senegal got her independence in 1960; however, while he was travelling on a research trip for his poetry, he got to meet the local socialist leader, Lamine Guèye, who advised him to run for election as a member of the Assemblée Nationale Française. In 1947, he left the African Division of the French Section of the Workers International (SFIO), which had given enormous financial support to the social movement. Senghor, along with Mamadou Dia, founded the Bloc Démocratique Sénégalais (1948). They won the legislative elections of 1951, while Guéye lost his seat. He became the first President of the Republic of Senegal, elected on 5th September, 1960.

Senghor is the author of the Senegalese National Anthem. By December 1980, he tendered his resignation as Head of State. He was replaced as head of the country by Abdou Diouf (Wikipedia, 2012). He spent his last years in Verson, where he died on 20th December, 2001. His funeral was held on 29th December 2001 in Dakar.

Towards an African Socialism

Senghor accepted socialism as a way to move Africa forward; however, he rejected the Marxists version of socialism which has atheistic tendencies. Thus, the employment of Karl Marx's and Engels' socialism would be grossly inadequate. He thinks that they can only serve as secondary sources in the development of an African socialism and not as primary sources. African socialism, he maintains, must be based on Negro-African cultural values. He criticised Marx's socialism as pitched on a materialistic foundation. He rejected Marx's

dialectical materialism and proposed an African Socialism that would be a democratic socialism, which integrates spiritual values. Furthermore, he observes that in Marxist communism, the suppression of the individual under the group, the person under the class and reality under ideology, is against African socialism. The formulation of African socialism, Senghor believes should be based on three steps:
1. Bringing to light the traditional civilization as the root of African socialism.
2. The study of the impact of colonialism on African civilization.
3. A synthesis of African socialist root with the values assimilated from European civilization.

The Senghorian Negritude

The word *Negro* refers to a people of a designated colour: black. And this identity of the African has been a source of ridicule from the West; at one point everything dark was inferior and devilish. It was in response to this background that Leopold Senghor developed a colour based identity for the African. He maintained that the black colour of the Negro, rather than demean him, assigns him a unique place in the world community.

Western cultural superiority advocated by the colonialist and rationalists tradition awakened the consciousness of blacks to assertive effort in articulating cultural rationalism among the French speaking Africans. The concept of negritude sprang up as the culmination of that desire earlier conceived as a celebration of the black endowment and drive

for the restoration of the dignity of the black race. While Senghor studied and taught at the University of Paris, he met prominent social scientists such as Marcel Cohen, Marcel Mauss and Paul Rivet. Along with other intellectuals of the African diaspora who had come to study in the colonial capital. Senghor coined the term "negritude", in response to the racism still prevalent in France. By so doing, the racial slur "nègre" was turned into a positively connoted celebration of African culture and character. The idea of negritude informed Senghor's cultural criticism and literary work, and also became a guiding principle for his political thought in his career as a statesman. According to Senghor, "Negritude is the whole complex of civilized values cultural, economic, social and political which characterize the black peoples, or more precisely, the Negro-African World" (1965, p. 83).

Negritude as a concept sought to reverse the colonialist portrayal of things African as evil, subhuman, or at least inferior to all things European. Senghor (1965) believes that every African shares certain distinctive and innate characteristic, values and aesthetics. In the poem 'New York', Senghor expresses that the black community of Harlem should 'Listen to the far beating of your nocturnal heart, rhythm/ and blood of the drum' and 'let the black blood flow into/ your blood' (p 157). The word nocturnal is interesting because it refers to the image of night. By using the imagery of night, Senghor is asserting that one's African heritage (one's Blackness) is both inescapable and natural (like night-time). Negritude, for Senghor (1993) "is the active rooting of a Black identity in this inescapable and natural African essence" (p. 27). According to Oyekan (2008), even

in colour symbolism, negritude asserts that black is more beautiful than white and soft dark night is preferable to harsh daylight. For several years, this movement exercised a powerful influence over francophone black literature. Senghor (cited by Abanuka, 2011) avers that in the negro-African world:

> Every Object is a symbol of an underlying reality that constitutes a veritable meaning of the sign which is immediately given to us. Every form, surface, and line, every colour and shade every smell and odour, sound and its has its meaning. (p. 85)

Senghor (1967), in his poem *Black Woman* goes further to romanticize the beauty of the black colour:

Naked woman, black woman

Clothed with your colour which is life, with your form which is beauty!

In your shadow I have grown up; the gentleness of your hands was laid over my eyes.

And now, high in the sun-baked pass, at the hearts of summer, at the heart of noon, I come upon you, my promised land, and your beauty strikes me to the heart like the flash of an angle. (p. 96).

In his poem, "Black", becomes "life and beauty". This symbolizes what blacks stand for: beauty and life. He maintains that the work of the black has distinction, not in

substance or subject matter but rather in a special approach, method and style. These he says:

> ...are essentially informed by intuitive reason.... In other words, the sense of communion, the gift of rhythm, such are the essential elements of negritude, which we find indelibly stamped on all the works and activities of the black man. (p. 83).

These distinctive black values are not just meant for the African and his world, it is the contribution of Africa to the civilization of the world. Thus, negritude is Africa's contribution to world civilization. It is not ideologism, radicalism or a false myth. It is the whole man: body and spirit in its search for universal explanation and realization.

From the Senghorian perspective, negritude is a philosophy of rediscovery and cultural reawakening, a philosophy of cultural emancipation aimed at giving the African people a sense of pride and dignity in their identity as Africans, by making them appreciate the value of their culture as distinct from the French culture and identity.

Senghor (cited by Nwoko, 1988) points out four dimensions of negritude:
1. Cultural negritude, highlights the role of emotion as dominating the entire Negro-African cultural system. He emphasizes that religion is deeply part of Negritude and cannot be removed from it. Senghor (1975) states that, "it is their emotive attitude towards the world which explains the cultural values of the African.... Their religion

and social structure, their art and literature, above all, the genius of their languages" (p. 35). He believes that the reinforcement of man is at once the reinforcement of other created things and the reinforcement of God form in whom all forces are accomplished. The ancestors are the oldest human expressions of God (Janet, 2008).

2. Social negritude, places the family at the centre of the social structure. Thus, man as a person realizes his being in the family structure, and the society has meaning from what the family is. The idea of family here according to Senghor (1959), embraces "the sum of all persons living and dead, who acknowledge a common ancestor... the ancestral lineage contuse to God" (p. 2). The ancestors are dead, they no longer have bodies nor do they have vital breath. But, that they are not perfectly dead. They are made to participate in the reinforcement of the vital force to the Community. Thus, sacrifice offered to the ancestors constitutes the "Cult" of the negro. Thus religion occupies a significant place in his philosophy.

3. Economic negritude, which holds that in the African traditional society there is no personal property. He exemplifies this with the question of land which cannot be owned as wealth or property since it is considered a force or spirit. Labour in the Senghorian Negritude is collective and free, which does not diminish a person but rather fulfils the person (Nwoko, 2006).

4. Political negritude, which is based on the belief that the federal system of government is the only kind of democracy that would help Africa. For Senghor (1964), democracy is the traditional form of Negro-African societies and this he derives from the absence of classes in traditional African societies before colonialism. The federal democracy which he advocates for is a unitary decentralized state. Individual states of the federation, with their assemblies and governments will direct their local welfare according to the will of the people. He strongly believes that while the decentralization of power brings economic and political responsibilities closer to the people, the centralization of power brings about bureaucracy.

Conclusion

A cursory glance at the works of Senghor reveals that more than any other African philosopher, he focused serious attention on the great accomplishment and continuing energy of African art, underlining in his own poetry the beauty of image and rhythm that is so much a part of African literary inheritance. His whole philosophy of negritude was a reaction to the assimilation assumption of France that African culture was essentially inferior to the French. As a growing African elite, he responded by devoting himself to becoming a writer, student of history and language. He sought in this way to demonstrate that African culture was as valid and existing as any other.

References

Abanuka, B. (2011). *A history of African philosophy.* Onitsha: Spiritan Publication.

Collins, R. O. (1990). African history: Western African history. Liberian Inaugural. *President Leopold Senghor to Retire.* 1980-12-03.

Digne Souleymane (2012). Negritude. Ed. N. Z. Edward. The Stanford Encyclopedia of Philosophy. Retrieved 27th October 2012 from http://plato.stanford.edu/archievessum2010/entries/negritude

Janet, V. (2009). *Leopold Senghor.* Microsoft(R) Encarta(R) 2009(DVD). Redmond WA: Microsoft Corporation, 2008.

Kanu I. A. (2012). The colonial legacy: The Hidden History of Africa's Present Crisis. *An International Journal of Arts and Humanities. 1.1.* 123-131.

Kanu I.A (2012). *African philosophy.* Unpublished Lecture Note. St Augustine's Major Seminary, Jos. 16/10/12.

Makumba, M. (2005). *Introduction to philosophy.* Kenya: Pauline Publications Africa.

Nwoko, M. (2006). *Baisc world political theories.* F. O. C Njoku (ed.). Enugu: Snaap Press.

Oyekan, O. (2008). African literature. Microsoft(R) encarter2009(DVD). Redmond WA: Microsoft Corporation.

Senghor, L. S. (2012). Retrieved 26th October 2012 from http://en.m.wikipedia.org/wiki/Leopold_sedar_Senghor.

Senghor, L. S. (1975). What is negritude? (Eds.) G. C. M. Mutiso and S. W. Rohio. *Readings in African Political Thought* (pp. 78-90). London: Heinemann.

Senghor, L. S. (1959). Elements of constructifs d'ume civilization d'inspiration negro-africaine. *Presence Africaine. February – May.*

Senghor, L. S. (1964). On African socialism. Trans. M. Cook. New York: F. A. Praeger.

Senghor, L. S. (1993). Negritude: A humanism of the twentieth century. P. Williams and L Chrisman (Eds.). *Colonial discourse and post-colonial theory (pp. 27-35).* London: Longman.

Senghor, L. S. (1965). New York (Jazz orchestra: solo trumpet). In J. Reed and C. Wake (trans.). *L.S. Senghor: Prose and Poetry (pp.155-157).* Oxford: Oxford University Press.

Teilhard de Chardine (1959). *The phenomenon of man.* London: Collins.

JULIUS NYERERE

(1922-1999)

Introduction

African philosophy has been concerned with a reflective investigation into the marvels and problematics that confront one in the African world, be it religious, economic, social or political. As a field of knowledge cultivated within time, it consists of four Periods: The Ancient Period, the Medieval Era, the Modern and Contemporary Epochs. The Ancient Period covers basically the philosophers of ancient Egypt. The Medieval Era of African philosophy was highly dominated by Christian theologians and philosophers who used philosophy as the handmaid of theology. The Modern Season of African philosophy, according to Abanuka (2011) is predominantly political, which reflected on the socio-political issues of the African continent. The socio-political situation of Africa, which was basically that of colonialism, in the contention of Pantaleon (1986), questioned the minds of African thinkers, and stimulated their thoughts on political issues. Thus, many Africans began the search for an ideological project of self-affirmation and assertive

cultural nationalism (Makumba, 2007). Among these were Nnamdi Azikiwe, the Pilot of Nigerian Independence (Nwoko, 2006), Leopold Senghor, appraised as an apostle of negritude, Kwame Nkrumah, a radical nationalist and a proponent of Pan-Africanism, Obafemi Awolowo, a socialist oriented nationalist, Julius Nyerere, the father of Ujamaa Socialism (Kanu, 2010). This notwithstanding, this work is streamlined to attending to Nyerere's Ujamaa socialism as a quest for an African community-based identity.

The Man Julius Kambarage Nyerere

Julius Nyerere remains one of the outstanding figures in African history. He was a politician of principle and intelligence popularly called *Mwalimu*, which means Respected Teacher. Born on 13th April 1922 in Bukiama on the eastern shore of Lake Vitoria in North West Tanzania. He was the first president of Tanzania from 1964-1984. Alongside Kwame Nkurmah, he was one of the brains behind the Organization of African Unity (O.A.U), now African Union. His ideas, according Nwoko (2006) were formed by those of Kwame Nkrumah, Kenyetta, Mahatma Gandhi, Luthuli, John Kennedy, Teilhard de Chardin and Pope John XXIII. A cursory glance at his works reveals that he shared in their beliefs about equality, human dignity and the unity of all mankind.

At the age of twelve he began his academic pursuit with great enthusiasm. He was a devoted Catholic and a tutor in a Catholic institution before studying history and economics in Britain. He is best known for "Ujamaa", which simply

mean *family-hood*. As the founder and leader of TANU (Tanganyika African National Union), a post he held till 1977, he advocated for peaceful change, social equality and ethnic harmony. As a president, he collectivized village farmland, carried out mass literacy campaigns and instituted university education.

In 1979, he authorized the invasion of Uganda to overthrow Idin Amin. He began to develop his particular vision of connecting socialism with African communal living. He contributed to the throwing off of white supremacy government in South Africa, Rhodesia and North West of Africa. After retiring from politics in 1990 he devoted the rest of his life to farming and diplomacy and on 14th October 1999, in a London hospital, he died of leukaemia. His major political writings and speeches have been collected into the following volumes: *Ujamaa- Essays on Socialism (1968), Uhuru na Umoja-Freedom and Unity (1969), Uhuru na Ujamaa-Freedom and Socialism (1969), Uhuru na Maendeleo (1973)*.

The Emergence and Nature of Ujamaa Socialism

Tanzania as we have it today is a unification of former Tanganyika and Zanzibar colonies. They came together on 23rd April 1964 and signed an act of union that made their countries one nation officially called United Republic of Tanzania with Dar es Salaam as its capital city. Tanzania is a collection of over 120 different tribal groups, with no dominant group. However, Swahili and English are the country's official languages.

Political organization was hierarchical with the noblest holding high offices. In some lesser centralized tribes such as those who were nomads, political systems were based on age grade organization, which ensured strict allocation of functions according to age grades. Land belonged to all the subjects of that given territory, with the chief acting as an arbitrator in times of land or cattle disputes. Life was communal with each one's misfortune or need being solved and fulfilled with the community as a whole. This was the structure and the functioning of pre-colonial chieftainship. The common factor that can be drawn from such a social organization was the need to face life's challenges communally. These factors seem to be the features that later inspired the Tanzanian President, Mwalimu Julius Nyerere into claiming that his ideology was the essence of the African state.

The advent of the colonial powers brought formal education into Tanzania, even though the aim is debatable. Was the aim to train Tanzanians into being knowledgeable for their own self determination in the future? Or was it just to train clerks to handle information in colonial offices to cater for the need to run exploitative colonial state machinery? The latter argument is supported by the fact that, the British ruled Tanzania for 43 years and by the time they left, they left only two trained engineers and 12 trained doctors. Nevertheless, it was from among these colonial educated Tanzanian elites that emerged leaders who strongly stood for Tanzania's independence in 1961. Among those who fought for Tanzania's independence, was Mwalimu Julius Nyerere (1922-1999).

Out of his enthusiasm for the development of his poor country, he introduced a political concept that was meant to merge socialism with traditional tribal government. Nyerere agrees with both Nkrumah and Senghor that capitalism and individualism are foreign to Africa, and that traditional African society is communalistic and as such, individualism should be rejected. He pointed out three basic features peculiar to African traditional society that supported Ujamaa:

a. communal ownership of land;
b. everyone was a worker and wealth did not give anyone the power to oppress the other;
c. everyone enjoyed the security and hospitality provided by the community. This is not to say that African traditional societies were rosy. He equally pointed out some elements that must be excluded from Ujamaa. These include, the inferior position given to women and the traditional level of poverty due to ignorance and low scale operation. By the late 1960's, Tanzania was one of the world's poorest countries. Like many others, she was suffering from a severe debt burden, a decrease in foreign aid and a fall on the price of commodities. His solution was a blend of socialism and communal life. Nyerere (1968) points out the vision of Ujamaa in the Arusha Declaration of 1967 thus:

> The objective of socialism in the United Republic of Tanzania is to build a society in which all members have equal rights and equal opportunities; in which all can live in peace with

> their neighbours without suffering or imposing injustice, being exploited or exploiting; and in which all have a gradually increasing basic level of material welfare before any individual lives in luxury. (p. 340).

This Arusha Declaration made it part of her ambition to build a Tanzanian State. As a document, it took its name from a small northern Tanzanian town Arusha. The Arusha declaration contains the aims and objectives of Ujamaa socialism. Mutiso (1975) observes that it was divided into five parts, covering the ideological and political means of how socialism in Tanzania could be achieved.

1. First part concerns its creed which stated that all human beings are equal and its aim was to safeguard this principle.
2. Part two concerns the policy of socialism which shall ensure the absence of capitalism and exploitation in the state of Tanzania. Therefore the major means of production and exchange will be under the control of peasants and workers through the machinery of government (Vrenzak, 2006).
3. The third part was about the policy of self reliance. The Poor man can't use money as a weapon because he doesn't possess it; therefore it is stupid to rely on money as the major instrument of development. Foreign financial assistance will endanger independence, as it would limit the choice of policies. Thus, Tanzanians must avoid taking loans and gifts from other countries. First of all Tanzanians have to rely on what they already have:

land peasants and agriculture. Self-reliance means that Tanzanians will have to depend on their local resources. The development of a country is to be brought about by people, not by money. Money and wealth is the result, not the basis of development (Vrenzak, 2006).

4. Part four was about TANU (Tanganyikan African National Union) membership. It stated that every member of TANU had to accept the faith and objectives of socialism.

5. Part five emphasized that every TANU and government leader should not be associated with any practices of capitalism, including holding shares in any company or even to own houses for renting (Vrenzak, 2006).

In socialist Tanzania, agricultural organization was predominantly that of co-operative living and working for the good of all. This means that, most of their farming would be done by groups of people who live and work as a community. Nyerere's Ujamaa represents the hopes of many in the 1960s who wished to carve out an independent socialist pathway different not only from the acquisitiveness of Western capitalism, but also from the totalitarian forms of communism in Russia and China.

Nyerere, with his socialist ideology, envisaged a society made up of atomic family units, a country made up of Ujamaa villages with mutual co-operation and collaboration. Such a nation would be basically family unit extended to embrace the whole society. The capitalistic spirit of acquisition,

individualism, the exploitation of man by man, class struggle and conflict, which widens the gap between the rich and the poor and which further creates the aperture for exploitation, will all be excluded from that society. He regards the capitalist attitude as acquisitive and the socialist as distributive. He further distinguishes between European socialism and Ujamaa socialism; while the former is a glorification of European capitalism and a product of class wars, the latter is the way of life of the African people. Unlike the latter, Nwoko (2006), observes that it acknowledges the functioning of religion and creedal tenets on God. It advocates for the society aiming at self-reliance and self-liberation. He believes that the elimination of colonialism, exploitation and promotion of equality from the society would bring about the liberation of the individual.

Generally, the aim and objectives of Ujamaa Socialism can be understood as follows:
1. To safe guard the interest of Africa and emphasize African unity.
2. To prepare people for self government and independence and to relentlessly fight tribalism and build up a united nation, to secure elected African majorities on public bodies, to advance education, trade unions, co-operatives, to oppose discrimination, land alienation.
3. The Ujamaa socialism emphasizes certain characteristics of traditional organization and extending them so that they can embrace the possibilities of modern technology and enable them to meet the challenges of life in the twentieth century world.

4. Ujamaa aims at re-establishing traditional African democracy and social security.
5. To eliminate colonialism or foreign reliance so that African rulers will identify themselves with the African masses. Thus, every individual will be liberated, which would foster development.
6. To eliminate ignorance by embarking on mass education and mobilization.
7. To build up a familyhood where there would be no conflict, struggle or tension.

Equality, Freedom and Unity

The political ideas of Julius Nyerere were guided by his principles of unity, equality and freedom. Nyerere (1968) writes:

> There must be equality because on this basis will men work co-operatively, there must be freedom because every individual is not served by the society unless it is his, and there must be unity, because unless the society is united can its member lived and work in peace, security and well being. (p. 23).

Drawing from a wide variety of both European and African theories of state and social development, his unique governing philosophy (Ujamaa) created a thought that guided Tanzania on a path of peace and stability and provided the social infrastructure for stable and equitable economic development. The policy of Ujamaa laid a ground work for a unified nation that overcame ethnic and linguistic differences.

At the heart of Nyerere's political values was an affirmation of the fundamental equality all humankind and a commitment to the building of social, economic and political institutions, which would reflect and ensure this equality. In the late 1950s, while arguing the case for Tanganyika's independence, Nyerere (2012) declares:

> Our struggles have been, still and always will be struggles for human right. Our position is base on the belief in the equality of the human being, In their rights and their duties as citizens. He also declared that discrimination against people because of their colour is exactly what we have been fighting against. (p. 24).

Ujamaa according to Nyerere is like a democracy, and the principle of equality is a determinant factor in every genuine democracy. This equality must be reflected in the political organization of the state, as there should be equal participation in the administration of the state. It is this right to equality that gives people the opportunity to choose who their leader will be.

Perspective on Exploitation

If the idea on equality must thrive, Nyerere believes that every form of exploitation will have to be removed from the society. Dugan and Civille (1976) avers that Nyerere understands exploitation thus:
1. Making a living from the work of others;

2. Making an amount of money that is out of proportion with respect to the rest of society;
3. A rich person making profit from a poor person;
4. Taking more than one needs;
5. Inordinate greed for power and prestige;
6. Manipulation through laziness, negligence, cheating, insincerity, dishonesty, lack of co-operation;
7. An uneven distribution of social amenities;
8. Making money without working.

He posits that exploitation emerges when an individual has power over the lives of others; when one man controls the means of production, the means through which another earns the essentials of life, which is characteristic of capitalism. In this process, the rich will become richer and the poor poorer, losing all access or control over their future. At the world level, exploitation abound. On the economic level, the rich countries control market values for the goods produced by the poor ones. On the political level, the rich countries force a relationship on the poor countries so that the poor are later constrained to follow the policies dictated by them (Nwoko, 2006). Nyerere makes particular reference to IMF as a Western instrument for controlling the economy of the Third World.

Education for Self Reliance

Nyerere maintains that the traditional level of poverty in traditional African societies were due to ignorance. He avers that education is a basic for reducing the level of poverty in the society and that the education provided by Tanzania

for her citizens must serve the purpose of Tanzania: the local interest of the people; it must encourage the growth of the socialist values; it must encourage the development of a proud independent and free citizenry which relies upon itself; it must ensure that the educated know themselves to be an integral part of the nation and recognize the responsibility to give greater service. It will be wrong if education brings about the continuation of inequalities. A student should be educated to be a member and servant of the kind of just or egalitarian future which Tanzania aspires.

Perspective on Racism

In his thought on racism, Nyerere (1968) acknowledges that all human flesh is of one kind; and that all humankind is of the same specie. Thus, there should be no discrimination; the fact that one is white and the other black does not make any unhuman. His idea in this regard is based on his Ujamaa familyhood, and which extends beyond the family nucleus, beyond the tribe, and beyond the community and the nation to include the entire humanity. It creates a society where everyone is cared for and not discriminated against.

As one of the founding fathers of O.A.U he laid the foundation for the African continent to start its long and arduous road towards peace and unity. He believes that international harmony and peace for happy race relation can be achieved only when mutual sympathy and respect are upheld and reciprocated. White and black must work together to make harmonious human race possible.

Evaluation and Conclusion

Nyerere's policies of nation building amounted to a case of unsung heroism with wise and strong leadership, and a brilliant policy of cultural integration. He took one of the poorest countries in the world and made it a proud leader in African affairs and an active member of the global community. Through one-party rule and emphasizing racial and tribal harmony and moralistic sacrifice, Nyerere unified Tanzania from a far flung collection of tribes into a nation.

However, a cursory glance at the thoughts of Julius Nyerere, reveals that his vision was bigger than his victories and his perception deeper than his performance. In global terms he was one of the giants of the 20^{th} century. Like all giants, he had both great insights and great blind spots. His vision did out-space his victories, and his profundity outweighed his performance. His policies of 'Ujamaa' amounted to a case of heroic failure. They were heroic because Tanzania was one of the few African countries which attempted to find its own route to development instead of borrowing the ideologies of the West. It was a failure because, in a bid to avoid any form of Western influence (neo-colonialism) Tanzania had to break diplomatic ties now and then with Western countries. Nyerere refused taking loans and grants from them; a move which seriously impoverished the people and left the nation very poor. Thus, the economic development plan did not deliver the goods of development.

Internally, according to Vrenzak (2006) there was lack of commitment towards forming a state based on Ujamaa

principles. This was one of the major reasons that could not sustain Ujamaa as a national ideology. Even among high ranking leaders in the then ruling party TANU, few believed in Ujamaa. Many saw the attainment of independence as a chance to accumulate wealth through their positions as ministers, party leaders or any high ranking position in a state institution. This caused passive discontent on the part of the masses. It also led to mismanagement, misallocation of funds and corruption. Ironically, not one of those responsible was ever disciplined. It was such that at the time he was leaving office after being in power for nearly three decades, Tanzania was an independent state, but far from being self-reliant, with government budget heavily subsidized from foreign aid and the debt burden crippling even further the economy. State machinery was insufficient and corruption rife. After Nyerere stepped down from power in 1985, the country was in shambles, and the socialist experiment was viewed as a failure. Nyerere apologized and resigned voluntarily after serving four terms.

It is true that the Ujamaa socialism encouraged the unity of distinct communities in Tanzania to become one. But this was done without due consideration of the individuality of each community. They were stopped from speaking their various languages to embrace Swahili as a national language. There was a call for centralization, and in this process the chiefs who were in charge of the various communities were forcefully relieved of their duties. There is nothing traditional in the central government of Tanzania. In the process of constructing Ujamaa, African democracy was destroyed.

The one party system which Nyerere advocated for, is one of the instruments of dictatorship, even if he may not have been a dictator in the true sense of the word. There is no watch dog to act as a gadfly for the party government. Nyerere though a politician, talk authoritatively as if he was the only person that all must answer, which made him pay deaf ears to some of his critics. Nyerere's TANU was almost a communist party which had the final word in government.

Ethnic diversity remains an important aspect of social life irrespective of the level of development in Africa. If Africa manages well and integrates properly her diverse ethnic nationalities and multi-culturalism, it could become one of her special gifts to the modern world. With her rich and vast culture and artistic heritage, Africa is a potential tourism market place where her customs and traditions will readily position her as a preferred top destination for international tourists who want to see something new, exciting and vibrant, like the African cultural practices that are different from the Western values.

Although Nyerere's socialism suffered some setback, Mutiso (1975) maintains that Nyerere's effort to realize the ideals of his village, was an encouragement to rediscover the spiritual and humanistic principle of African personality. Nyerere should be commended for his efforts. To stand the attacks on Tanzania caused by his anti-imperialist policy in other to liberate his people from the fetters of colonialism, neo-colonialism and racism can only be carried out by a strong willed man of the calibre of Nyerere. He was a man who was unflinching in his determination, unconfused in his

means and goals and restless in the pursuit of justice and equality for all. He remains an ideal that has set the model to revolutionize and Africanize by building on the values and innate potentials of African people. Julius Nyerere had good plans for his people; he wanted to build something African, that which will embrace the African spirit of communalism. He wanted to eliminate the spirit of individualism and capitalism which was associated with the western world. Though he failed due to many setbacks which his socialism suffered, he deserves applause for having a thought of rediscovering the spiritual and humanistic principles of African personality, that is, his effort in bringing to Tanzania some kind of ideology that is based on the communalism of Africa in contrast to capitalism and individualism.

References

Pantaleon, I. (1994). *Enwisdomization and African philosophy*. Ibadan: International university Press.

Omoregbe, J. (1990). *Knowing philosophy*. Lagos: JOJA Edu-Research and Publishers.

Ali, A. and Toby, K. (1986). *The African*. New York: A Reader Publication.

Mutiso, G. C. (1975). *Readings in African political thought*. Ibadan: Heinemann Educational books.

Njoku, F. O.C. (2002). *Essays in African philosophy, thought and theology*. Enugu: Snaap.

Ochieng-Obhiambo, F.A. (2009). *Companion to philosophy*. Nairobi: Consolata Institute of Philosophy.

Abanuka, B. (2011). A history of African philosophy. Enugu: Snaap.

Makumba, M. (2007). *Introduction to African philosophy.* Kenya: Pauline.

Nwoko, M. (2006). *Baisc world political theories.* F. O. C Njoku (Ed.). Enugu: Snaap.

Kanu, A. I. (2010). The political philosophy of Azikiwe as the ideology of political regeneration for Nigeria. *Professor Bassey Andah Journal of Cultural studies. 3.* 146-155.

African National Congress (2013). Retrieved 6th March 2013 from www.anc.org.za/andocs/history/people/Nyerere/index.html-4k

Vrenzak, J. (2006). *Political philosophy.* Unpublished lecture Notes. St Augustine's Major Seminary, Jos.

Nyerere, J. (1998). *The ethical foundation of his legacy.* Canada: University of Toronto.

Nyerere, J. (1968). *Freedom and socialism.* Oxford: Oxford University.

Nyerere, J. (1968). *Ujamaa: Essays on socialism.* Oxford: Oxford University.

Dugan, S. W. and Civille, J. R. (1976). *Tanzania and Nyerere: A study of Ujamaa and nationalism.* New York: Orbis Books.

Nkrumah, K. (1969). *Handbook of revolutionary warfare: In dark days in Ghana.* New York: International Publishers.

OBAFEMI AWOLOWO

(1909-1987)

The Man Obafemi Awolowo

Awolowo was born in 1909, in Ikenne, Ijebu Remeo of Western Nigeria. Nwoko (2006) describes him as a journalist, an active legal practitioner, politician and educationist. About him, Omoregbe (1990) writes, "An eminent thinker with deep prophetic insight, He is a convinced and uncompromising advocate of socialism. In his political life he has consistently been on the left wing and the critical side in an essentially capitalist society". (p. 52). His first name *Obafemi* means 'The king loves me' and the surname Awolowo means 'The mystic, or mysticism, commands honour or respect'. He was commonly known as *Awo* or *the Sage*.

During his career, he served as a teacher in Abeokuta, and subsequently, as a clerk at the famous Wesley college. In 1949 Awolowo founded the *Nigerian Tribune*, the oldest surviving private Nigerian newspaper, which he used to spread nationalist consciousness among Nigerians. He started his

career as a nationalist in the Nigerian Youth Movement. As a young man, he was an active journalist and trade unionist, editing *The Nigerian*. After earning a Bachelor of Commerce degree in Nigeria, he went to the UK where he earned a law degree from London School of Economics. While there, he founded the *Egbe Omo Oduduwa*, a Pan-Yoruba cultural society, which set the stage for the formation of the Action Group, a liberal and nationalist political party. As Leader of the Group, he represented the Western Region in all the constitutional conferences intended to advance Nigeria on the path to independence.

He was the first Premier of the Western Region under Nigeria's parliamentary system, from 1952 to 1959, and was the Official Leader of the opposition in the federal parliament to the Balewa government from 1959 to 1963. In addition to these, Awolowo was the first individual in the modern era to be referred to as Leader of the Yorubas (*Asiwaju Omo Oodua*), a title which has come over time to be conventionally ascribed to his direct successors as the recognised political leader of the elders and young members of the Yoruba clans of Nigeria.

In his work *Path to Nigerian Freedom (1947)*, he was the first Nigerian politician to put into writing the first systematic federalist manifesto. He advocated for federalism as the only basis for equitable national integration and, as head of the Action Group, he led demands for a federal constitution, which was introduced in the 1954 Lyttleton Constitution. He supported limited public ownership and limited central planning in government. He believed that the state should

channel Nigeria's resources into education and state-led infrastructural development. Controversially, and at considerable expense, he introduced free primary education for all in the Western Region, established the first television service in Africa in 1959, and the Oduduwa Group, all of which were financed from the highly lucrative cocoa industry which was the mainstay of the regional economy. Awo was not just a journalist, an active legal practitioner, politician and educationist, he was also a visionary and a philosopher. Among his major political works are: *Path to Nigeria Freedom (1947); Thoughts on Nigerian Constitution (1966); The People's Republic (1968); The Strategy and Tactics of the People's Republic of Nigeria (1970); and The Problems of Africa (1977)*.

Political Anthropology

Awolowo (1968) believes that a person is composed of both the mental and physical element. He developed the theory of mental magnitude which rests on the philosophical belief that the mental (*reasoning*) is superior to the physical elements of a person. It places reflective thinking at the heart of human actions. Given this basic belief, therefore, commonsense holds that human desires and actions can only be defended reasonably when they follow the dictate of reason. Like Plato, he acknowledges the existence of the mind and body, but goes further to divide the mind into two, namely, *conscious* and *subconscious* phases. The conscious phase is sub-divided into two sectors: the *objective* and the *subjective* minds. The subconscious phase is also sub-divided into *unconscious* and *superconscious* minds. Awolowo (1968) sees the subjective mind as the seat of thinking and

reasoning, while the objective mind is connected to the faculties of seeing, smelling, feeling, tasting and hearing. Thus, while the subjective coordinates the rational level of man, the objective coordinates the sensual.

He thinks that the objective mind needs an object to be able to function, while the subjective mind does not require any object since it is purely mental. Its functions include observation, imagination, inference and others. Indeed, the most active phases of the mind are the subjective and subconscious minds. The subconscious mind is physical (a network of automatic nerve), mental (because it reasons deductively) and spiritual, since it is the projection of the essence of God.

Awolowo proposes what he referred to as mental magnitude, which he says is necessary so as to allow *reason* (that is, reflective thinking) to control human instincts and emotions. Thus, the theory of mental magnitude is about a person's ability to subvert the human desires that crave selfish interest and crass materialism. The theory is borne out of Awolowo's observation that most leaders lack the basic ingredients of leadership, namely, *self-discipline*. He shares this view with Plato who has earlier observed that the interests of politicians are sometimes in conflict with the interest of the people, especially when the politicians' desire is simply to satisfy their needs.

Agreeing with Plato, Awolowo (1968) avers that the body or appetite must be governed by the soul or mind. He makes it 'an immutable law' that the soul commands while the body obeys. When reason fails to govern our emotions

and instincts, the mind becomes corrupted leading to all sorts of evil such as greed, bribery, nepotism, abuse, misuse of power, cheating, embezzlement, smuggling, violation of the laws of the land, violence and gangstarism. What should constitute a good society is the egalitarian spirit through which true meaning is given to human existence, individually and collectively. A leader should learn to lead himself first before he can aspire to lead to others. The governance of soul or mind over the whole self, would lead the eradication of the following:
1. Negative emotions of anger, hate, fear, envy or jealousy, selfishness or greed;
2. Indulgence in the wrong types of food and drink, ostentations consumption;
3. Excessive or immortal craving for sex. According to Awolowo (1968) in this regime of mental magnitude, men and women conquer what Kant calls "the tyranny of the flesh," and become free (p. 230).

In establishing a nexus between man and the state, he avers that man is a social animal and that the state is an organised or ordered association. This goes back to Aristotle (1962), who says that "Man is by nature a political animal" (p. 15). Awolowo (1968), agreeing with Keeton, defines the state as "an association of human beings whose members are at least considerable, occupying a defined territory, and united with the appearance of permanence for political ends, for the achievement of which certain governmental institutions have been evolved" (p. 83). He believes that the fundamental purpose for the establishment of the state is for the good of man. Awolowo (1979) thus writes:

> ... All the three organs of the state- the legislature, the executive and the judiciary as well as all social institutions are designed by him to ensure a congenial atmosphere for his economic advancement and prosperity and to regulate economic regulations... (pp. 54-55).

Man is, therefore, at the centre of his political philosophy. Among other problems, the state is meant to tackle the economic problems of man: food shelter, clothing etc. From the foregoing, it is obvious that with Plato (1941), Awolowo agrees that the state originated because of human material needs and the need for social support among men. Aristotle (1962), had also seen the political society as existing to serve man's needs, to provide the individual with the means and circumstances which will enable him to develop himself and gain the goal of life, namely, happiness.

Capitalism and Socialism: The Case of Africa

The quest to tackle the economic problems of man, according to Awolowo (cited by Nwoko, 2006) has led to the emergence of two scientific attempts: capitalism and socialism. According to Azikiwe (1981), "Capitalism is a socio-economic system essentially based on private ownership of capital goods or means of production. It is profit oriented and profit motivated" (p. 20). It is usually associated with freedom of industry or enterprise: freedom of private property, choice, equal opportunities and promotion of egoistic altruism. It has motivated the growth of arts and industry and the improvement of the tools of production.

On the other side, it has encouraged, greed and self-interest. It has introduced *laissez faire* and abolished mercantilism.

Awolowo (1979) criticizes capitalism on the grounds that it does not reward the four agents of production equally; it would rather leave labour at the mercy of the owner of production. He argues against the idea of choice which capitalism is said to bring by asking what choice are available to the average African who tills the soil. As regards equality, he says that capitalism does not provide grounds for equality as it can never offer the same equality for labour and the owner of land and capital. He thus concludes that capitalism is an incurable exploitative and corruptive system, activated by selfish motives and bound to impoverish the helpless masses to the advantage of the rich few.

Disenchanted with capitalism, Awolowo explores socialism. Socialism is characterized by public ownership of means of production, distribution and exchange. It aims at organizing the state as a fraternal, co-operative commonwealth, with fair and equal distribution of wealth. It rejects class-division and *laissez-faire* philosophy. He accepts the understanding of socialism as issued by Marx and Engels. They conceive socialism as the next stage after capitalism in the progress of economic process of history. This gradually leads to communism, a point where all the traces of capitalism is finally wiped off. This will also imply a movement from state, with its capitalist elements to community. Awolowo, while accepting their thoughts on socialism rejected that of communism. He encouraged the unity of all men, the public ownership of property like land and service according to ability and reward according to deed. Comparing socialism

to capitalism, Awolowo argues that although capitalism feigns to provide for the material wellbeing of the populace, socialism is the sure and under-feasible winner.

Awolowo's analysis thus far, was directed towards the development of a political system that would suit the political situation in Africa. He listed out the problems in Africa that need to be addressed:
1. the problem of underdevelopment, which comprises economic underdevelopment and poor health and exploitation;
2. the problem of individual freedom and sovereignty, which includes freedom in election and civil rights;
3. the problem of a realistic constitution that would fit the multi-ethnic nature of African societies;
4. and the problem of African unity.

To solve this problem, African's must make a choice between socialism and capitalism. Adopting socialism, he rejects capitalism. He adopts socialism on the ground that it would help for "the full development and full employment of every African" (Awolowo 1979, p. 61). Socialism would tackle the underdevelopment of the subjective mind, typified by ignorance, illiteracy and deficiency in techniques and organization; the underdevelopment of the body, typified by disease, calorie deficiency, bad water, bad housing and filthy environment; underdevelopment of agriculture, unemployment and excessive rural population typified by lack of savings and capital formation. He believes that socialism would provide free education at all levels, free health services and employment for all Africans.

Education and the Development of Africa

To tackle the problems of Africa, Awolowo (1968) believes that Education must be given a priority. This is further based on his observation that the phenomenal rise from underdevelopment to development in nations such as the USA, Japan and USSR were due to education. He defines true education as the development of the mind, body and brain. At this point, he distinguishes between education that focuses on acquisition of certificates and laurels, and education that involves the development of the 'whole person'. Education in the former sense does not involve the education of the body, mind and brain while in the latter sense education is holistic. It is a form of education which injects into an individual the ability to reflect on his/her actions, thought and deeds.

Awolowo (1968) contends that if a man's body is developed and his brain and mind are not developed he stands to be exploited. On the other hand, if a man's mind is developed and the brain and body are not developed he becomes a religious fanatic, pessimistic and fatalistic. Those who engage in terrorism for religious purposes fall within this category. Nevertheless, this is where he thinks that education can forge the links required for the functions of the body, brain and mind. Into his philosophy of education, he brings in his idea of mental magnitude. He is cocksure that those who acquire the right education are those who have cultivated the regime of mental magnitude, self-discipline and spiritual depth.

Interestingly, Awolowo (1968) introduces two forms of education, one for the masses and the other one for leaders. His major concern for the masses is to educate them so that they can overcome the problem of ignorance, illiteracy and superstition. The leaders are to receive a higher education that will free their minds from instinctual enslavement. It was this notion that made Awolowo to introduce Universal Primary Education in Western Nigeria. He probably thinks that basic education is enough to liberate the people from ignorance and superstition while the leaders are exposed to rigorous education which bothers on his theory of mental magnitude. While emphasizing a kind of education for leaders, Awolowo reveals his great dependence on Plato who had earlier held a view that the State should have a special education for the Guardians.

Religion and the Cultivation of Mental Magnitude

Awolowo, like other African nationalists believes that religion has a place in national development. The religious dimension, he argues is meant to strengthen or bring to completion the idea of mental magnitude. Spiritual depth is that which one must possess not sidelining mental magnitude. It is from this perspective that Makinde (2007) avers that 'From the epistemological point of view, Awolowo's philosophical position seems to have a Cartesian flavour; like Descartes, he seems to give a prominent role to God in man's acquisition of knowledge' (p. 179). He maintains that it is from God that love ultimately emanates. God is seen by him as the universal mind of which the human mind

is a copy or image, and which pervades all things. He says that the cultivation of mental magnitude emanates from our understanding of God; the ultimate Realty, as the universal mind of which this mental magnitude is an image.

Awolowo's view seems to confirm the claim of Mbiti (1970) that the African lives in a religious universe where God, as the ultimate Reality, is used to explain all things and events, including laws of nature and human custom.

> Wherever the African is, there is his religion. He carries it to the fields where he is sowing seeds or harvesting new crop, he takes it with him to a beer parlour or to attend a funeral ceremony; and if he is educated, he takes religion with him to the examination room at school or in the university; if he is a politician, he takes it to the house of parliament. (p. 2)

Awolowo gives a prominent role to God in his epistemology. That is to say, God is to be seen as the ultimate source and guarantor of our ideas or knowledge. Also, his concept of God as the universal mind is very much like that of Bishop George Berkeley. For Berkeley, 'to be is to perceive' (case at percipi). In order to avoid the problem of the continued existence of objects when they are not being perceived, Berkeley (1988) postulates God whom he calls the universal mind Who perceives all things when we do not perceive them.

Awolowo on Good Governance

Awolowo (1968) defines good governance as adherence to accountability, transparency, the rule of law and human rights policies. This is laced with love, social justice, equity and fairness. Every good leadership, therefore, should translate these values (love, justice and fairness) into reality. Thus, the test of good governance is in the preservation of a peaceful and just social order with a wide range of opportunities such as liberty, fairness, good education and legal equality, among others. Awolowo (1968) believes that corruption in government arises when a leader's mind is not developed. There were three classes of people in the Nigerian society of his time: the educated class, which consists of professional people, teachers and clerks; the enlightened class, consists of traders and artisans and lastly the ignorant masses. He believes that good government is meant to ensure the well-being of these various groups in the society, the preservation of justice and gender equality.

He approached Nigeria's political development from the standpoint of social transformation, namely, the removal of ignorance and illiteracy among the citizens, and the education of the leaders. He sees ignorance and illiteracy as the major impediments to the achievement of good governance. The problem of illiteracy often manifests itself in two basic areas: the illiterate electorate who aid rigging, and incompetent leaders who aid corrupt individuals in the society.

References

Awolowo, O. (1968). The People's Republic. Ibadan: Oxford University Press.

Awolowo, O. (1979). The problems of Africa: The need for ideological appraisal. London: Macmillan.

Makinde, M. A (2007). *African philosophy: the demise of a controversy*. Ile-Ife. Obafemi Awolowo University Press.

Omoregbe, J. (1990). *Knowing Philosophy*. Maryland. Joja.

Obafemi Awolowo (2012). *Chief Biography*. Retrieved on the 20th November, 2012.http://www.bookrags.com/biography/obafemi-awolowo-chief

Redmond, W. A. (2008). Obafemi Awolowo. Microsoft® Encarta® 2009 [DVD]: Microsoft Corporation, 2008. retrieved on the 20th November, 2012.

Wikipedia (2012). *Obafemi Awolowa*. Retrieved, 21th November, 2012 from *en.wikipedia.org/wiki/Obafemi_Awolowo*.

Berkeley, G. (1988). A treatise concerning the principle of Human Knowledge. London: Penguin Books.

John Mbiti (1971). *African religions and Philosophy*, London: Heinemann

Descartes, R. (1989). *Discourse on method and meditations*. Trans. John Veitch. New York: Prometheus Books.

Nwoko, M. (2006). *Baisc world political theories*. F. O. C Njoku (ed.). Enugu: Snaap Press.

Nnamdi Azikiwe, *Ideology for Nigeria: Capitalism, Socialism or Welfarism* (Lagos: Macmillan, 1981), p.20.

Aristotle (1962). Politics. London: Penguin Books.

Plato (1941). The republic of Plato. Trans. F. M. Cornford. London: Oxford University Press.

KWAME NKRUMAH

(1909-1972)

Introduction

Kwame Nkrumah was one among the notable African Nationalists of the 20th century. He was born on 18th September, 1909 at Nkroful in Western Ghana. He trained as a teacher at Achimota School in Accra from 1927 to 1930 and for the next five years, he taught in several schools in the Gold Coast. He had his post secondary education in the United States of America and in Britain from 1935 to 1947. He enrolled in Lincoln University in Pennsylvania, where he graduated in 1939 with a B. A. and received a bachelor of Sacred Theology in 1942. Nkrumah earned a Master of Science in Education in 1942 at the University of Pennsylvania and Master of Arts in Philosophy in 1943. He taught political science at Lincoln and also preached at black Presbyterian churches in Philadelphia and New York City.

He has a couple of achievements attributed to him. In London, he helped organize the fifth Pan-African Congress in Manchester, England, during which he served as the

Secretary General of the Conference. Then he founded the West African National Secretariat to work for decolonization of Africa. In early 1947, Nkrumah was invited to serve as the General Secretary to the United Gold Coast Convention (UGCC), which marked the beginning of his quest for Africa's liberation and unity. According to Ebenezer (1982), he quickened the pace of liberation in Africa and inflamed revolution in many parts of the African continent. Nwoko (2006) avers that he was the first African leader to attract international fame and represents for the black world a symbol of unity. The Organisation of African Unity (OAU) is his brain child.

On 10th March 1952 Nkrumah was elected the Prime Minister of Ghana and on March 6th 1960, he announced plans for a new constitution which will make Ghana a Republic. On 19th, 23rd and 27th April 1960, a presidential election was held during which he emerged as president. He was overthrown by a section of the Ghanaian Army led by the late General Emmanuel Kotako and late General Amansa Akwasi Afrika in a coup d'etat. He died in exile on 17th April, 1972 at Bucharest, Romainia at the age of 63, six years after he was overthrown. He has the following works attributed to him: *Towards Colonial Freedom (1962); Africa Must Unite (1963); Conscientism (1964); and Autobiography (1965)*.

Colonialism and the Liberation of Africa

Nkrumah's political ideology springs from his criticism of the imperialist's government for their intention to perpetually

dominate Africa. This domination he believed was expressed in the monopoly of capital by the imperialists against their dependent colonies, the financial enslavement of the world's majority, the emergence of unequal development and struggle between the rich and poor countries (Nwoko, 2006). Nkrumah looked forward to a time when the forces of European exploitation of Africa will destroy its own working principles. According to Nkrumah (1962), its destruction of its own working principles will begin with the emergence of a colonial intelligentsia, the awakening of a national consciousness, the emergence of a working class movement and the growth of a national liberation movement, which will tend towards the establishment of a free press to stir up political consciousness and educate the people on their rights and freedom; it must also have a good social, economic and political plan. According to Nwoko (2006), Nkrumah's liberation movement aims at three spheres: political freedom, in terms of independent government; democratic freedom, in terms of a democracy whose sovereignty is vested in the masses; social reconstruction, which includes freedom from poverty and economic exploitation.

Closely related to imperialism is neo-colonialism. Nkrumah christened neo-colonialism as the highest stage of imperialism. He sees it as imperialism abandoning its old form of naked exploitation and to enter the neo-colonial stage. In the neo-colonial state, the old exploitation continues but this time the supervisors are the national bourgeoisies. Three methods of exploitation are noted.
1. First, the multinational corporations supervise one aspect of the exploitation;

2. second, Balkanization also enables neo-colonialism to continue;
3. finally, those who provide aid to the African countries subtly ensure its perpetuation.

Afari-Gyan (1976) avers that in Nkrumah, the concept of neo-colonialism parallels that of socialism in importance. He sees neo-colonialism as the number one enemy of Africa's development. Therefore, Asante (2010) avers that socialism as developed by Nkrumah is an antidote to neo-colonialism and anything that promotes the growth of socialism serves to frustrate neo-colonialism.

Conscientism as a Path towards Liberation

Nkrumah's search for the right formula for the decolonization of Africa reached its pick with his development of the idea of conscientism. The reason for the need for philosophical conscientism was built on the irreversibility of the dynamic changes which had taken place in African societies under the influence of alien religious and political cultures, together with the view that for any institution or ideology to be effective, it must relate to the conditions of the people it seeks to serve.

According to Nkrumah (1964), African history through the centuries has accumulated much of confused teachings and orientations from external influences: colonial imperialists, Islamic and Euro-Christian elements, thus producing equally a confusing and conflicting vision. The situation has been worsened by the deceptive presentation of African

history as a story of Western adventure. To undertake fully the venture of the unification and liberation of Africa, a reforming, revolutionalizing and inspiring philosophical system is indispensable. He calls this system *Philosophical Conscientism*. It would serve as a "body of connected thought which will determine the general nature of our action in unifying the society which we have inherited, this unification to take account, at all times, of the elevated ideals underlying the traditional African society" (p. 78). According to Nwoko (1988), this would further equip the African to sift and blend appropriate values for the major elements of African history to form or fit the African personality. To help resolve the crisis of conscience already created by the contact between Africa and the West, Nkrumah (1964) writes that,

> Our philosophy must find its weapons in the environment and living conditions of the African people. It is from those conditions that the intellectual content of our philosophy must be created. The emancipation of the African continent is the emancipation of man. This requires two aims: first, the restitution of the egalitarianism of the human society, and, second, the logistic mobilization of all our resources towards the attainment of that restitution. (p. 78).

He believes that this would help bring about the total liberation of the African person.

Pan-Africanism

The Pan-African movement, as a unique cultural and spiritual movement for the promotion of the black race, was dedicated to the establishment of independence for African nations and cultivating unity among black people throughout the world. It encourages the solidarity of Africans, based on the belief that Africa's unity is vital to economic, social, and political growth in Africa and that the fates of all African peoples and countries are intertwined, they share not merely a common history but common destiny. As a concept, it was not first used by Nkrumah, Pan-Africanism was already in use in the works of black Americans and West Indians in the early 19th century (Legum, 1962). It originated during the conferences held in London in 1900, 1919, 1921, 1923 and other cities. W. E. B. Du Bois was a principal early leader (Nkrumah, 1963). The important sixth Pan-African conference (Manchester, 1945) included Jomo Kenyatta and Kwame Nkrumah. The first truly intergovernmental conference was held in Accra, Ghana, in 1958, where Patrice Lumumba was a key speaker. The Pan-Africanist Congress (PAC) was founded by Robert M. Sobukwe and others in South Africa in 1959 as a political alternative to the African National Congress, which was seen as contaminated by non-African influences. The founding of the Organization of African Unity (OAU) now the African Union (AU) in 1963 was a milestone, and the OAU soon became the most important Pan-Africanist organization.

In early 1958, as earlier indicated, Nkrumah invited all independent African states to a conference in Accra to

discuss issues of mutual interest. Nkrumah (1963) avers that the reason for the conference was to:

> ...exchange views on matters of common interest; to explore ways and means of consolidating and safeguarding our independence; to strengthen the economic and political ties between our countries; to decide on workable arguments for helping fellow Africans still subject to colonial rule; and to examine the central world problem of how to secure peace (p. 132).

Further, the reason for this first historic gathering of purely African states leaders is for them to know themselves, get to share ideas affecting them individually and generally. In this conference, Nkrumah (1963) spoke of the great dangers of the growth of Africa, which are colonialism and racism.

What Nkrumah wanted was total continental political integration. The continental union was to have three main objectives: overall continental planning on a continental scale; a unified land, sea, air, military and defence strategy and a common foreign policy. Nkrumah emphasized that the interests of neo-colonialism and the objectives of African governments are directly opposed, for whereas the strength of African countries lies in their unity, the strength of neo-colonialism lies in their disunity. He believes that a united socialist Africa is a necessary condition for the realization of the African Personality.

To boost the unity of Africa, he wrote a work titled, *Africa Must Unite*. In this work, he proposed the need for the

establishment of a People's Party which will promote the establishment of a central organisation and political solidarity in Africa. Nkrumah (1963) writes that:

> We need the strength of our combined numbers and resources to protect ourselves from the very positive dangers of returning colonialism in disguised forms. We need it to combat the entrenched forces dividing our continent and still holding back millions of our brothers. We need it to secure total African liberation. (pp. 216-222).

As regards defence, he further argues that:

> If we do not unite and combine our military resources for common defence, the individual states, out of a sense of insecurity, may be drawn into making defence pacts with foreign powers which may endanger the security of us all. (pp. 216-222).

With the dawn of the colonial era, Kanu (2012) argues that former independent African communities lost their political liberty with the division of the African continent into a patchwork that showed little regard for ethnic or linguistic boundaries. It is in this regard that Davidson (1995) opines that African communities were squeezed into about 50 colonies, marked out by frontiers. Thus, the Somali people were divided into four colonial systems: some were under the British, some under the Italians, some under the French and others under the Ethiopians. We also have some Hausas under the British rule in Nigeria and others under the French in Niger. As a result, people who were bound by

ties of culture, language or even blood were divided by new territorial frontiers, which made them citizens of different states. Nkrumah (1963) however avers that the arbitrary partition of Africa should not discourage us towards the quest for unity. For in practice, such a unity requires a common political basis for economic planning, defence, foreign and diplomatic relations.

To help the unity of Africa, All-African People's Conferences championed by Nkrumah was opened in 1958, which organized several conferences. In 1963, in conjunction with other African nationalists, the Organization of African Unity (OAU) was established, now known as African Unity (AU).

Conclusion

The essential features of Nkrumah's political thought include: an undivided Ghana-united in true independence; one united and indivisible continent of Africa. This can be achieved through a continental union government; large scale socio-economic reforms to eliminate and eradicate all colonial institutions; the struggle for economic independence of African states based on socialist principle; establishment of African high command to combat all imperialist and racialist forces in Africa; advocate a socialist democracy that will give the people control over the means of production and distribution.

In Nkrumah, we find a representation of the struggle for a free and democratic Africa. As Haberman (2012) puts it, "it is a law of life". The continuity of this struggle is

evident in the fact that his theory of neo-colonialism is still very valid today; with the implementation of the Structural Adjustment Programs (SAPs) in Africa, most African countries, including Ghana, cannot truly claim that they possess economic independence since the decisions for implementation of the SAPs was taken in New York and the West.

A cursory glance at the Pan-Africanist position reveals that its advocates often champion socialist principles and tend to be opposed to external political and economic involvement on the continent. As an ideology, it homogenizes the experience of people of African descent.

References

Ebenezer, B. (1982). *The Ghana revolution from Nkrumah to Jerry Rawlings.* Enugu: Dimension.
Arhin, K. (2001). *The life and work of Kwame Nkrumah.* Accra: Sedco.
Haberman, L. (2012). *The Journal of Pan African Studies*, 4.10.
Afari-Gyan, K. (1976). *The political ideas of Kwame Nkrumah.* New York: African Heritage Studies.
Asante, S.K.B. (2010). *In search of African unity: Ghana's pivotal role.* In Daily Graphic, 10th May.
Nkrumah, K. (1962). Towards colonial freedom. London: Panaf.
Nwoko, M. (2006). *Basic world political theories.* F. O. C Njoku (Ed.). Enugu: Snaap.
Nkrumah, K. (1964). *Conscientism.* London: Heinemann.
Legum, C. (1962). Pan-Africanism. London: Oanaf.

Nkrumah, K. (1963). *Africa must unite.* London: Oanaf.

Davidson B. (1995). *Modern Africa: A social and political history.* London: Longman.

Kanu, I. A. (2012). The colonial legacy: The hidden history of Africa's present crisis. *An International Journal of Arts and Humanities. 1. 1. 123-131.*

FRANTZ FANON

(1925-1961)

Introduction

Jinadu (1980) argue that in some way or the other political thinkers are the product of their social milieu. He writes, "There is necessarily a sense in which political thinkers are products of their social milieu. Their thoughts and writings are profoundly affected by the complex nature of the various social influences and forces to which they are exposed and subjected" (p. 20). While Freud placed great emphasis on the ontogenetic, Fanon (1967) emphasizes the influence of the environment. He avers that, "…every neurosis, abnormal manifestation, every effective erethism in an Antillian (his home town) is the product of his cultural situation" (p. 152). He thus emphasizes the relationship between social structure and the individual.

This perspective explains why it is significant to study the relationship between man and his ideas and the connection between a man's thoughts and the milieu or environment within which he lived or thought. There will always be found

social, historical, biographical and intellectual contexts that determine and shape the thinking of thinkers. Frantz Fanon is no exception. According to Jinadu (1980), "In the case of Fanon, his writings on colonialism are rooted in the socio-economic and political milieu created by French colonial rule in Martinique and Algeria" (p. 21). He had a socio-political context, which was the colonial society and the quest for liberation guided his thoughts in the search for an African revolution. This chapter would focus on Frantz Fanons political philosophy.

The Life of Frantz Fanon

Frantz Fanon was born in Fort-de-France on the Island of Martinique. He was a son of a descendant of African slaves; his mother was said to be an illegitimate child of African, Indian and European descent, whose white ancestors came from Strasbourg in Alsace. Socio-economically, the family of Fanon was middle class, and thus could afford the fees for the Lycee Schoelcher, the most prestigious high school in Martinique, where the writer Aime Cesaire taught. He grew up in a racially mixed society of Martinique, with values and schooling modelled after those of France.

During the Second World War (1939-1945) he worked with the Free French forces in North Africa and France from 1947 – 1951, during which he attended a Medical School in Lyon, France, and began a residency in psychiatry. After his return to Algeria, he was appointed chief psychiatrist at a hospital in Blida, Algeria in 1953. In 1956 Fanon resigned his post at the hospital and joined a guerrilla army, the *Front*

de Liberation Nationale (Algerian National Liberation Front or FLN) that eventually forced France to accept Algeria's independence.

He enlisted in the French army and joined an Allied convoy that arrived in Casablanca. He was later transferred to an army base at Bajaia on the Kabylie coast of Algeria. Fanon left Algeria from Oran to serve in France, notably in the battles of Alsace. In 1944 he was wounded at Colmar and received the Croix de Guerre Medal.

Fanon's work reflects the intellectual influences of his years in France, where he was drawn to the group of black intellectuals associated with the *Journal Presence Africaine*. He was also close to a group of French intellectuals associated with the *Journal les Temps Moderlles* that included Jean Paul Sartre, Maurice Merleau-Ponty and Albert Camus. These two groups and writings of the German philosophers Karl Marx and Georg Wilhelm, Fredrick Hegel strongly influenced Fanon's political and philosophical orientation. As a practicing psychiatrist in Algeria, he was convinced of a close connection between the individual pathologies of his patients and the political situation. He concluded that colonialism causes a unique pathology in both the colonized and the colonizer, and the only cure is a revolutionary struggle by the colonized to free themselves from colonial rule. Fanon articulated these ideas in his political writings. In 1959, he published *A Psychiatric Study of Colonialism*; Fanon, F. (1967). *Black skins, white masks*; Fanon, F. (1967). *Towards the African Revolution*. Fanon, F. (1968). *The wretched of the earth*. Fanon, F. (1994). *A dying colonialism*.

In his final years of life, Fanon visited Ghana, Mali, and other African countries as an FLN representative.

The Political Sociology of Colonial Society

The concern of Fanon was basically to resolve the problems of Black-White relationship, which was fostered by colonialism and colonial rule. Writing on his reason for criticizing colonialism, Fanon (1989) avers, "Someone to whom I was talking about this book asked me what I expected to come of it... This book, it is hoped, will be a mirror with a progressive infrastructure, in which it will be possible to discern the Negro on the road to disalienation" (pp. 183-184). He targets to bring about social and political change, to disalienate both the colonizer and the colonized.

At the time of Fanon, Algeria was under France, and there was a philosophy that underlay the French colonial rule. It was evident in their policies of assimilation and association, even though the word assimilation is commonly used to speak of the French colonial policy. As a philosophy, it believed in the inequality of human beings and the superiority of French culture and civilization, and thus, the denial of the authenticity of indigenous culture. In the contention of Hodgkin (1957), the policy of assimilation was a "constitutional fiction" (p. 38). It was far from being realized and thus created a gap between theory and practice. Through assimilation, the French colonial powers wanted to create in Martinique and Algeria a French elite from among the people who, according to Buell (1928) will serve as instruments of French colonial rule. All the oppressions of

the time were hidden under the table of bringing civilization to the colonized. Lewis (1952) maintains that "less a generous urge to extend to benighted peoples the blessings of French civilization than the need to provide justification for the maintenance of French rule" (151). This was the perspective propagated by Marx and Engels that colonialism substituted civilized institutions for barbarous ones. This, in the view of Irele (1969) led nationalists like Fanon to attempt to rediscover their African heritage and to assert a racial pride and consciousness.

Developing an underdevelopment theory, they argue that colonialism was unprogressive, rapacious, exploitative and disruptive to the development of the history of the colonized people. In the contention of Fanon (1968), "It is violence in its natural state" (p. 61). Kabwegyere (1972) quoted Mr. George Wilson, a British Colonial administrator in Uganda who wrote about the violence he generated, "Recently, I have been compelled to assert my authority in a manner that has caused serious loss of life and property. To allow uncivilized races to defy authority is a sure way of losing it, and my action therefore was imperative" (p. 305). Beyond physical violence, there was also structural violence, which Fanon (1967) describes as the Manichaeism of the colonial situation. He writes:

> The colonial world is a world divided into compartments. It is probably unnecessary to recall the existence of native and European quarters, of schools for native and schools for Europeans: in the same way we need not to recall apartheid in South Africa. (p. 37).

A Study in African Socio-Political Philosophy

Reacting to this violence, Fanon (1967 and 1968) argues that it has a way of not just destroying the colonized but also boomeranging on the colonizers; it can lead to the importation of the violence methods into the country of the colonizers. He sees Fascism and Nazism as manifestations of the violence effected on the colonized by the colonizer. Reacting to the alleged superiority of French culture, he asserts that all cultures are equally valid and that moral standards not absolute or universal.

Violence and the Colonial Situation

Kedouri (1970) describes Fanon with great exaggeration as "the most eloquent panegryst of ... violence, a writer who celebrates it with savage lyricism" (p. 139). He has an ambivalent stance on the issue of violence: his thought on the colonial situation is inherently violent and his justification of violence as a potent instrument of violence. According to Jinadu (1980):

> He condemns the violence inflicted on the colonized by the colonizer. According to him, such violence is not conducive to the self-realization of the colonized. But he also celebrates the instrumental value of violence as a means to a desirable end when socially organized and ideologically directed to achieve the liberation of the colonized. It is in this sense that he regards violence as the praxis of decolonization and freedom as self-realization. (p. 43).

Contrary to the law of dialogue, he proposed violence as a means of fighting colonialism. He argues that colonialism is not a thinking machine nor a body endowed with reasoning, and thus to begin to dialogue or appeal to the consciences of colonizers would be a waste of time, since the lack of reasoning and thinking places them outside the parameters of dialogue. The persistence of social injustice drives men to the conviction that the best way to help their situation is to resort to the use of physical violence. And he maintains that violent confrontation between the colonized and their colonizers in Algeria gave rise to the emergence of the new order and a new consciousness. Fanon (1968) writes:

> The mobilization of the masses, when it arises out of war of liberation, introduces into each man's consciousness the ideas of a common cause, of a national destiny, and of a collective history. In the same way the second phase, that of building up the nation, is helped on by the existence of this cement which has been mixed with blood and anger. (p. 93).

He, however, observes that sometimes, this fight is based on the inordinate ambition of the colonized to gain the position of the colonizer, which is envied by the colonized. Fanon (1994) opines, "The look that the native turns on the settlers town is a look of lust, a look of envy; it expresses his dreams of possession- all manner of possession" (p. 47). If this be the case, it can be argued that the structural violence brainwashes, indoctrinates and decreases the victim's mental potentialities, and thus alienates the colonized. It is, therefore, not surprising that the colonized rejects his

indigenous values and institutions believing that they are inferior to those of the whites. He apes the language, intonation and mannerism of the white man, thinking of himself as progressing while he is alienating and emptying in self-realization.

Language and Colonialism

Fanon (1967) thinks that one of the ways through which the colonized suffer alienation of psychological violence is through language. He understands language as a means of communion and an expression of brotherhood. He insists that to speak is to "exist for the other" (p. 17). Although a means of communication, language is also a means of transmitting knowledge from one generation to another. In relation to colonization, he argues that speaking the language of the colonizer instead of one's own language is *ipso facto* to assume the colonizers culture and to reject one's own culture. This promotes cultural and political domination. Language is thus part of a person's culture, and Fanon (1956) defines culture as the "…combination of motor and mental behaviour patterns arising from the encounter of man with nature and with his fellow man" (p. 32). He, therefore, sees the use of foreign language as an instrument of colonialism.

Fanon's Concept of Liberation

Fanon's concept of liberation goes beyond the search for spiritual freedom. According to Jinadu (1980):

> It implies the removal of a whole arsenal of socio-economic, cultural and political restrictions imposed on the colonized man- restrictions that limit the area of choices and opportunities that are available and open to him. Fanon's position is that the extent of one's freedom is the function of socio-political institutions and practices; in other words, these institutions and practices can have either a liberating or constraining impact on individuals. In a colonial situation their impact on the individual is negative. (p. 66).

How then can a person gain freedom? He posits that one's freedom is a function of one's determination to act in other to remove obstacles that stay in one's way. This struggle is continuous until one attains the good life. It is a search for the truth and part of the continuing process in which man's potentialities are forever enlarged. Thus Fanon (1967) writes that he has "one duty alone: that of not renouncing my freedom through my choices" (p. 229). Within the context of colonialism, liberation becomes for Fanon decolonization or political independence, which will involve bringing to an end a colonial government and the transformation of the colonial situation in such a way that the numerically superior, though sociologically inferior may now become the numerically and sociologically superior. Thus, any decolonization that does not change the structures of colonialism is a false decolonization.

Fanon's Theory of Revolution

Inextricably bound up with Fanon's concept of liberation is that of revolution. He understands revolution as the political

act aimed at transforming the colonial situation. Angered by bestiality of colonialism, Fanon decided to procure a 'cure' and that is his involvement in the Algerian revolution in 1954-1962. Fanon believed that violent revolution is the only means of ending colonial repression and cultural trauma in the Third World. Violence he believes is a cleansing force. It frees the 'native' from his inferiority complex and from his despair and inaction; it makes him fearless and restores his self-respect. Thus, Fanon calls on the colonized to be ready for violence; for it seeks to put society somewhat in its right shape; making the first last and the last first. However, this is not to say that Fanon was advocating violence for its own sake, rather, he sees it as a prominent tool for 'righting' the wrongs exhibited in the society.

The idea of violence in revolution attracted his audience because he did not have to search too far for reasons to convince his audience. He pointed to the exploitative relationship that existed between the settlers and Africans. The settlers used every means possible to secure their economic interest, including extreme brutality, even at the cost of 45,000 lives in Setif, 90,000 in Madagascar, 2,000 in Kenya and 25,000 in German Tanganyika, he thus, urges Africans to answer violence with violence.

Evaluation and Conclusion

A general criticism levelled against Fanon by scholars like O'Brien (1965), Coser (1966) and Gottheil (1967) is that he is poor in systematization and coherence and that he is easily carried away by his emotions into issues under

discussion to the extent that he loses objectivity, which is indispensable for a balanced analysis of reality. Thus, Coser (1966) writes, "Frantz Fanon's *The Wretched of the Earth*... is badly written, badly organized and chaotic. The author's reasoning is often shoddy and defective. This is not a work of analysis. Its incantatory prose appeals not to the intellect but to the passions". (p. 298). The problem with this criticism is the obscurity of what it means by a work being systematic or coherent? And secondly, was that what Fanon set out to pursue? If he was able to pass his message without coherence and systematization, then these concepts need to be reassessed.

As a criticism against Fanon, Kedouri (1970) describes him as "the most eloquent panegryst of ... violence, a writer who celebrates it with savage lyricism" (p. 139). On the part of Arendt (1969), he considers Fanon's discourse on violence as rhetorically excessive. Scholars like Nghe (1963), Klein (1966), Rohdie (1966), Caute (1965) and Grendzier (1973) have opposed Fanon's position that violence provides relief. This position is based on the thinking that violence cannot give peace, for it cannot give what it does not have. However, Jinadu (1980) argues that the criticisms of these scholars are mistaken, and can only be considered as an interpretation.

Frantz's position that to speak the language of the colonizer is to assume the colonizers culture and his civilization is not always true. What about the colonizers in some other parts of Africa that spoke the language of their colonized. Does it mean that they have now assumed the culture and civilization of their colonized? Today we learn different

languages to help us communicate in our globalized world, not necessarily because we are ashamed of being black or feel better looked upon as white.

In the midst of all the criticisms against Fanon, he remains one of the figures in African history who has impacted on the historical situation of which he was part. He has influenced the political attitude of many and given great insight into the political development of colonial and postcolonial Africa. And if he had spoken with great passion, it is simply because of the depth of the abuse of the Martiniquan people by the French army during the time of Fanon, which reinforced his feelings of alienation and disgust with colonial racism.

References

Arendt, H. (1969). Reflections on violence. *The New York Review of Books. February.* 19-32.

Buell, R. L. (1928). The native problem in Africa. London: Macmillan.

Caute, D. (1965). Philosopher of violence. *Observer. October 10.* 90-98.

Coser, L. (1966). The myth and peasant revolt. *Dessent. 13. 3.* 203-211.

Fanon, F. (1967). Black skins, white masks. United States of America: Grove Press.

Fanon, F. (1967). Towards the African Revolution. United States of America: Grove Press.

Fanon, F. (1968). The wretched of the earth. United States of America:Grove Press.

Fanon, F. (1994). A dying colonialism. United States of America: Grove Press.

Gotthiel, F. M. (1967). Fanon and the economics of colonialism: A review article. *Quarterly Review of Economics and Business. 1.* 73-80.

Grendzier, I. (1973). Frantz Fanon: A critical study. New York: Pantheon.

Hodgkin, T. (1957). *Nationalism in colonial Africa.* New York: New York University Press.

Irele, F. A. (1969). Literature and ideology in Martinique: Rene Maran, Aime Cesaire, Frantz Fanon. *Research Review. 5. 3.* 1-32

Jinadu, L. A. (1980). *Fanon: In search of the African revolution.* Enugu: Fourth Dimension.

Kabwegyere, T. B. (1972). The dynamics of colonial violence: The inductive system of Uganda. *Journal of Peace Research. 4.* 300-307.

Kedouri, E. (1970). Nationalism in Asia and Africa. The World Publishing.

Klein, N. (1966). On revolutionary violence. *Studies on the Left. 4. 3.* 79-85.

Lewis, M. D. (1962). One hundred French men: the assimilation theory in French colonial policy. *Comparative Study in Society and History. 6. 2.*

Nghe, N. (1963). Fanon et les Probemes de l'Independence. *La Pensee.* 25-31.

O'Brien, C. C. (1965). The neurosis of colonialism. *The Nation. 200.* 670-678

Rohdie, S. (1966). Liberation and violence in Algeria. *Studies on the Left. 6. 3.* 82-88.

KENNETH BUCHIZYA KAUNDA

(1924- date)

Introduction

Kenneth Buchizya Kaunda popularly known as KK was born on 28th April 1924 in Lubwa Northern Province of Northern Rhodesia now Zambia, to Malawian parents at the hills of the watershed between the great Luangwa and Chambezi Rivers. His father was David Kaunda, a great African missionary of the Church of Scotland who died while Kaunda was eight. His mother was a teacher, who though poor, was able to save some money for his education. He was born at the twentieth year of the marriage of his parents, the eight in the line of children. He had his primary education at Lubwa and his secondary schooling at Lusaka. In August 1940, Kaunda (1981) wrote, "... the first secondary school was opened at Munali in Lusaka and in 1941 I was chosen along with twenty-nine other students from schools throughout the territory to take my form at Munali" (p. 13). This marked the beginning of his secondary school education. He was then just 17 years old. At Munali, he heard so much about apartheid. In his autobiography he writes:

> For the first time I understood the meaning of the word apartheid. I heard innumerable stories of the indignities which my fellow Africans suffered at the hands of fellow white men in the Union. Sometimes Sonquishe would say to me: 'Kenneth, it is almost too late for us to do anything about it in South Africa; we've lost our chance, but here it is not too late. Young men like yourself must make sure that what happened to us in the South will never happen up here. (p. 17).

This among others steered up his hunger for the liberation of Africans from their white oppressors.

In 1950, Kaunda entered politics as an organizer, quickly rose to the forefront of the anti-colonial freedom struggle, and in 1960 emerged as president of the United National Independence Party (UNIP). At the time of this struggle, Africans were not allowed to enter the European shops by the front door. If they wanted anything, they had to go through the hole on the wall. Ikeda (2005) quoted Kaunda's narration of his own experience thus,

> I went inside and asked politely for a book. . . . Pointing to the door, [the proprietor] said viciously, 'Get out of here.' I said again, 'I am only asking for a book and I can get it nowhere else in town.' He said, 'You can stand there till Christmas and you'll never get a book from me. (p. 1).

Blacks were also not allowed to eat in the same restaurants with whites. So many times Kaunda was thrown out of

restaurants and shops simply because he was black. At the time, the colonial government made little investment in education and medical care. It was so glaring after the British left, for only less than a 100 indigenous people were graduates. Parents worked from dusk to dawn to see that their children went to school. Thus at the age of 25, he began a successful nonviolent campaign against the white-dominated Federation of Rhodesia and Nyasaland, riding on his bicycles and with his guitar hung across his neck went about singing freedom songs. He later won a landslide election as prime minister of Northern Rhodesia (Zambia) in 1964. When independence was granted later that year, he was elected president.

Re-elected to a sixth presidential term in 1988, Kaunda was defeated in 1991 by Frederick Chiluba in Zambia's first multiparty election in 19 years. Chiluba came into the scene breathing out a fury for change, but he and his government failed to bring about much of the progress they had promised. According to Guest (2004), "the reforms stalled as Mr Chiluba's venal cronies began to loot the country. Corruption under Mr Chiluba held Zambia back as surely as Mr Kaunda's socialism" (p. 26).

In May 1996 the Zambian legislature passed an amendment to the constitution preventing presidents from serving more than two terms in office and requiring presidential candidates to be at least second-generation Zambians. The same court declared Kaunda a Malawian and also stateless. This effectively disqualified Kaunda for the November 1996 elections, which his party, the UNIP, then boycotted. Kaunda stepped down

as head of the UNIP and retired from politics in March 2000. To help the spread of his ideas, he published several books: *Zambia shall be Free (1962); A humanist in Africa: Letters to Colin Morris (1973); Letter to my children (1980); Kaunda on violence (1987); Humanism in Zambia and a guide to its implementation part I (1987); Humanism in Zambia and a guide to its implementation part II (1988); State of the nation. Volume I: Politics and government (2007).*

Kenneth Kaunda's Humanism

When Kaunda took over from British rule, his government chose an ideology: Zambian humanism. It was a form of African Socialism, which combined traditional African values with Western socialist and Christian values. This ideology was eventually declared Zambian national ideology and philosophy in 1967. The choice of this ideology was based on the fact that Africa had always contained much indigenous socialism which the colonialists had tried to destroy, and so the Zambian humanism was an attempt to rescue pre-colonial values and traditions and to use these as the basis on which to build the modern state. Like every other humanism, it set out to create a society that places the human person at the centre of all activity, social, economic and political. Describing the Zambian Humanism, Kaunda (2007) wrote,

> Zambian Humanism came from our own appreciation and understanding of our society. Zambian Humanism believes in God the Supreme Being. It believes that loving God with all our soul,

all our heart, and with all our mind and strength, will make us appreciate the human being created in God's image. If we love our neighbour as we love ourselves, we will not exploit them but work together with them for the common good (p. iv).

The Zambian humanism was also a Christian humanism because of the place it gave to God. Kaunda (1966) writes:

> By Christian humanism, I mean that we discover all that is worth knowing about God through our fellow men (sic) and unconditional service of our fellow men is the purest form of service of God. I believe that Man must be the servant of a vision which is bigger than himself; that his path is illuminated by God's revelation and that when he shows love towards his fellow men, he is sharing the very life of God, who is Love. (p. 39).

Thus, Zambian humanism is a Christian humanism because of the Christian principles basic in them: the concept of God as creator, including of the human person; the dignity of the human person; the equality of human beings, regardless of position in society. Because of the context it addresses, Schreiter (1985) refers to it as a local theology.

The basic principles of the Zambian humanism were enumerated by Kaunda (2007) as follows:
a. The human person at the centre – the human person is not defined according to his colour, nation, religion, creed, political leanings, material contribution or any matter.

b. The dignity of the human person - Humanism teaches us to be considerate to our fellow human beings in all we say and do.
c. Non-exploitation of Man by Man (sic) - Humanism abhors every form of exploitation of human beings.
d. Equal opportunities for all - Humanism seeks to create an egalitarian society--that is, a society in which there is equal opportunity for self-development for all.
e. Hard work and Self-reliance - Humanism declares that a willingness to work hard is of prime importance; without it nothing can be done anywhere.
f. Working together - The national productivity drive must involve a communal approach to all development programs. This calls for a community and team-spirit.
g. The extended family - under the extended family system no old person is thrown to the dogs or to the institutions like old people's homes.
h. Loyalty and patriotism - only in dedication and loyalty can unity subsist.

To ensure the implementation of the Zambian humanism, concrete measures were taken by the government. It was taught in schools and colleges. Those who were civil servants also had to go through various training sessions on Zambian humanism and in fact, their promotion depended on how much of it they knew. A government ministry was created to take charge of the spread of this philosophy: *National Guidance*. Seminars, workshops and short courses were also offered in universities on Zambian humanism. The

media was also expected to play a very significant role in this direction.

Kaunda was very empathetic. Ikeda (2005) quoted him to have said:

> I can still see clearly in my mind that day when I watched a group of poor African women being manhandled outside a white-owned butcher's shop because they were protesting against the quality and price of the rotten meat he was trying to foist off on them. I swore then never to eat anything my poorest fellow Africans could not afford. (p. 1).

Kaunda stressed the central role that education must play in the liberation of the African people. After Zambia's political independence, he built many primary schools and colleges to train nurses. He fought apartheid with a lot of vigour and passion and motivated the people to do the same. He writes:

> Today you have special branch of men and women following you wherever you go as if you were criminals; today you stand the chance of been sent to jail for shouting slogans like "freedom now"; today you are liable to be deported from your own home for the 'offence' of telling your people this was their country and their birthright to rule themselves. This is where we stand today. The terrible stories that have been written about struggling in India, Egypt, Ghana, and other countries that were once ruled by Britain, are taking place right her. (p.1).

According Kaunda (1980), in every situation of violence, the oppressed has three options to choose from: passive resistance, succumb to oppression or to come out in open revolt against it. He argues that succumbing to oppression is undignified and unworthy of any self-respecting man. On the other hand, open revolt often leads to killing of countless people, those very people for whom freedom is sort. So he decided to resort to the third method- the method of passive resistance or non-violence or positive action. Ikeda (2005) quoted him to have said:

> Our main armament was not guns but words-- thousands and thousands of words, written and spoken to rally our people, to lay our claims before the British Government and the world, to express our anger and frustration at the denial of our birthright to rule our own country. (p. 1).

And after independence he wrote, "Had we acted on the basis of a blow for a blow, the history of the last days of Northern Rhodesia and the first days of Zambia would have been written in blood." (p. 1).

Kaunda (1972) condemned laziness and called on conscientious workers to consider the interests of fellow workers and members of society in general. He believes that harm is done to others through laziness, drunkenness at work, or illegal strikes.

> This day, therefore, provides the workers with an important opportunity to ponder over the real significance of work in our lives, the very high place

which work occupies in the life of our Nation. No man, no nation can exist without work. All growth depends on activity — on work. Even animals have to work to obtain food. In our environment there can be no development, no progress, physical or intellectual, without effort. (p. 62).

He writes further:

Effort means work. So work is not a curse; indeed, among human beings it is the most cardinal of the means to manhood and a key factor to the development of our civilisation. The defence of our liberty, freedom and independence means work. The furtherance of the aims of freedom and independence, the realisation of our economic, social and cultural goals, demands hard work. The greatest asset of any nation is the spirit of its people, its working force; and the greatest danger than can menace any nation is the breakdown of that spirit — the will to work, the will to succeed and the courage and determination to work relentlessly towards greater victories. (p. 62).

Evaluation and Conclusion

To what extent did the Zambian humanism work? It looked so beautiful and promising, but its implementation proved very difficult. This could be attributed to the fact that Zambia is the first known country that has officially adopted humanism as national philosophy and to have

actively attempted to implement it. Thus, during translation from theory to praxis there was no place to look on to. As an ideology, it was never strongly rooted among the Zambians. Mwanakatwe (1994) posits that government officials paid mere lip-service without deep and genuine conviction that Zambian Humanism was useful in the nation-building effort. Among academics and intellectuals, Mwanlimu (2009) avers that they were reluctant to accept and propagate humanism because they found it to be neither an academic philosophy nor an ideology. Reason being that it lacked the theoretical base by which the world could be analyzed and from which action could be taken. According to Hall (1969), "Among the younger and better educated Zambians, there was also a sharp rise in cynicism" (p. 51).

A cursory glance at the situation in Zambia after Kaunda became the President, raises questions as to if the Zambian philosophy of humanism actually achieved its aim. This is because economic bankruptcy, political bias, religious discrimination, abject poverty, moral decadence and even illiteracy are still very much with the people of Zambia. The massacre of the members of the Lumpa Church, intolerance of opposition, the eventual banning of all parties except his own UNIP and his clinging to power until he was forced out of office in 1991.

Mwangala (2009) observes that the humanism of Zambia failed in economic terms. As a country, Zambia experienced several economic difficulties beginning from the mid-1970s. By the mid-1980s the country was worse off economically than it had been at the time of independence. The reasons

are very obvious: Kaunda's humanism was strongly opposed to capitalism as an economic system. Kaunda saw capitalism as encouraging the exploitation of human beings. In line with the new socialism, a number of private industries were nationalized, and the government became the main distributor of the wealth generated by the manufacturing industries.

These criticisms notwithstanding, Kaunda represents a figure among the people of Zambia that cannot be forgotten too soon; although not totally because of his contribution as a philosopher but as one courageous leader who actively participated in the independence struggle, and first president of Zambia.

References

Guest, R. (2004). *The shackled continent: Africa's past, present and future.* London: Macmillan.

Hall, R. (1969). *The high price of principles: Kaunda and the White south.* Middlesex: Penguin Books.

Ikeda, D. (2005). Dr. Kenneth, D. Kaunda- A Humanistic struggle. *SGI Quarterly. January. 1-2.*

Kaunda, K. (1972). *The dignity of labour.* Lusaka: The Cabinet Office/The Government Printer.

Kaunda, K. D. (1960). A speech issued at the meeting of the working committee of the United National Independent Party on August 1960.

Kaunda, K. D. (1966). *A humanist in Africa: Letters to Colin Morris.* London: Longmans.

Kaunda, K. D. (1980). *Kaunda on violence.* London: Collins.

Kaunda, K. D. (1981). *Zambia shall be free.* Britain: African Writers Series.

Kaunda, K. D. (2007). Zambian humanism, 40 years later. *Sunday Post*, October 28. 20-25.

Mwanlimu, M. R. (2009). *Found a modern nation-state on Christian values?: A theological assessment of Zambian Humanism.* Pietermartizburg: University of KwaZulu-Natal.

Schreiter, R. J. (1985). *Constructing local theologies.* London: SCM Press Ltd.

AFRICA AND THE ACTUALIZATION OF MILLENNIUM DEVELOPMENT GOALS

Introduction

Philosophers, scholars, activists, politicians, international organizations, development workers etc., for many years have engaged themselves with interrogations looming within the parameters of development, and the velocity in this direction has increased in tempo in the last few years. It has further given impetus to the emergence of the agenda of the Millennium Development Goals (MDGs), which conceives development as an attempt to improve people's lives by expanding their choices, freedom and dignity.

A cursory glance at the evolution of discourses in the academic and professional market regarding the status of the Millennium Development Goals, reveals a couple of arguments. These perspectives range from that of the high optimists, which sees the Millennium Development Goals

(MDGs) as the world's biggest promise and a global agreement to reduce poverty and human deprivation at historically unprecedented rates through collaborative action (Hulme, 2009), and thus, the blueprint for the transformation of the human condition (Sachs, 2005); we have the moderate critics who think that the MDGs are an attempt to distract humanity from focussing on more appropriate and effective policies and actions (Clemens et al, 2007; Easterly, 2006); there are the rabid critics, who view the MDGs as a conspiracy obscuring the really important 'millennial' questions of growing global inequality, alternatives to capitalism and women's empowerment (Antrobus, 2003; Eyben, 2006; Saith, 2006). These considerations, notwithstanding, this piece is not burdened by the analysis of the status of the Millennium Development Goals, neither does it intend to trek all the allies of the MDGs, rather, it focuses on the role of governments in the actualization of MDGs in Africa, with particular focus on the role of the Nigeria government.

The Millennium Development Goals (MDGs)

According to Hall (2005), the Millennium Development Goals (MDG's) are a linked set of objectives- a portfolio of targets that represent a coherent assault on the problem of development. Kingdom and Alfred-Ockiya (2009) aver that it expresses the shared commitment made by the Global Community to fight poverty. These MDGs, according to the *Consultative Group on International Agricultural Research* (2005) was endorsed by 189 nations as international commitment to the priorities for achieving sustainable development. It has 8 goals, 18 targets and 48 performance

indicators on poverty reduction, human well-being, social opportunities, economic conditions and a healthy natural environment. Broadly, these goals are to:
i. Eradicate extreme poverty and hunger,
ii. Achieve universal primary education,
iii. Promote gender equality and empower women,
iv. Reduce child mortality,
v. Improve maternal health,
vi. Combat HIV/AIDS, malaria and other diseases,
vii. Ensure environmental sustainability,
viii. Develop a global partnership for development.

From the foregoing, the MDGs focus on three major areas: human capital, infrastructure, and social, economic and political rights. In the area of human capital, it focuses on improving nutrition, healthcare (including reducing levels of child mortality, HIV/AIDS, tuberculosis and malaria, and increasing reproductive health), and education. In the area of infrastructure, it focuses on improving access to safe drinking water, energy and modern information/communication technology, amplifying farm outputs through sustainable practices, improving transportation infrastructure, and preserving the environment. In the area of social, economic and political rights, it focuses on empowering women, reducing violence, increasing political voice, ensuring equal access to public services, and increasing security of property rights. In sum, the MDGs can be described as the roadmap for world development by 2015. Although not a legally binding instrument, nor even a formal UN resolution, the MDG framework has in practice acquired a politically and morally compelling character.

Ikechukwu Anthony KANU

The Provenance of the Millennium Development Goals

In September 2000, the largest gathering of world leaders in human history was witnessed at the Millennium Summit at the United Nations headquarters, New York. At this Summit, representatives from the Member States of the United Nations reflected on their common destiny. As some States looked ahead to prosperity and global cooperation, many barely had a future, being mired in miserable, unending conditions of poverty, conflict and a degraded environment; it was this summit that provided a common lens for viewing reality (UNICEF, 2012). She equally adopted the United Nations Millennium Declaration, which were pregnant with the Millennium Development Goals (MDGs). The United Nations Millennium Declaration asserts that every individual has the right to dignity, freedom, equality, a basic standard of living that includes freedom from hunger and violence. All 193 United Nations member states and at least 23 international organizations agreed to achieve these goals by the year 2015 (Wikipedia, 2012).

The Millennium Summit Declaration was only a part of the origins of the MDGs. Institutions such as the Organization for Economic Cooperation and Development (OECD), the World Bank and the International Monetary Fund (IMF) played significant roles in the setting of the MDGs, which came about through a series of UN-led conferences in the 1990s focusing on issues such as children, nutrition, human rights, women, etc. The stroke that broke the Carmel's back was the UN's 50th anniversary celebration. Then, the UN

Secretary General Kofi Annan saw the need to address the range of development issues. This led to his report titled: *We the Peoples: The Role of the United Nations in the 21st Century*. This led to the Millennium Declaration. By this time, the OECD had already formed and pioneered a set of concrete development objectives that could be measured and monitored over time for shaping of the 21st century, which it called the International Development Goals (IDGs). This was combined with the UN's efforts in the World Bank's 2001 meeting to form the MDGs (Wikipedia, 2012). As such, The MDGs did not just come about through the effort of the United Nations, the Organization for Economic Cooperation and Development (OECD), the World Bank and the International Monetary Fund (IMF) worked together for its realization.

Nigeria and the Millennium Development Goals: Where we are!

From the Nigeria Millennium Development Goals Report (2010), it is obvious that in every MDG, there is a positive story to be told, even though there are large variations from state to state. Indices reveal that more children are surviving to their fifth birthday. More of them are starting school, and more are sufficiently nourished to be able to pay attention and learn. Their mothers have far less to fear about giving birth, and can be almost certain that their children will not succumb to polio. Parents can be increasingly ambitious for their girls as well as their boys. They have ever-increasing access to the technologies and opportunities that they need to earn an income to support those they love. And, as a

nation, Nigeria has turned the tide on HIV/AIDS, malaria and international debt. These notwithstanding, wide challenges still remain in every area of the MDGs. In this section, the researcher would go through the MDGs so as to study what remains to be done.

1. **Eradication of Extreme Poverty**

 In recent times, Sub-Saharan Africa has attracted a global publicity as a result of the high degree of poverty among its people. According to Oshewole (2011), Sub-Saharan Africa has, in fact, become synonymous with poverty, and Nigeria hosts the largest population of poor people in the region. Nigeria is a country with more than 150 million citizens and counting. Despite earnings of more than $300 billion from oil revenue (AFPODEV, 2006), Nigerians remain among the poorest in the world. 92% and 71% of the Nigerian population live on less than $2 per day and $1 per day respectively (AFRODAD, 2005). Despite several attempts by successive governments to ameliorate the scourge, the poverty situation in Nigeria is galloping and geometrically on the rise. Soludo (2003) avers that poverty is deep and pervasive in Nigeria, with about 70% of the population living in absolute poverty. Putting the problem in proper perspective, Nwaobi (2003) asserts that Nigeria presents a paradox. The country is rich but the people are poor.

 Today, Nigeria is ranked among the poorest countries in the world. Notwithstanding, as Okonjo-Iweala, Soludo and Muhtar (2003) observes

that the fight against poverty has been a central plank of development planning since independence in 1960, with about fifteen ministries, fourteen specialized agencies, and nineteen donor agencies and non-governmental organizations more than half of Nigerians still live below poverty line. Observers have unanimously agreed that successive government's interventions have failed to achieve the objectives for which they were established (Ovwasa, 2000; Adesopo, 2008; Omotola, 2008). The failure to effectively combat the problem has largely been blamed on infrastructural decay, endemic corruption, and poor governance and accountability (Okonjo-Iweala, Soludo and Muhtar 2003).

2. Universal Primary Education

From the Nigeria Millennium Development Goals Report (2010) nearly nine out of ten children, 88.8%, are now enrolled in school. The United Nations Development Programme (2007), reports that in 2005 about 84 out of 100 school age children attended school and an increasing number stayed there through to Grade 5. Net enrolment ratio in Primary School Education was 84.26% in 2005 as against 81.1% in 2004. The literacy rate among 15-24 years olds also improved from 76.2% in 2004 to 80.20% in 2005. The success was bolstered by the implementation of the Universal Basic Education, improved policy environment and better intergovernmental coordination in the sector.

The prospect of achieving the goal is, therefore, very bright. Nevertheless, regional differences are stark. State primary completion rates range from 2% to 99%. In particular, progress needs to be accelerated in the north of the country if the target is to be met. Low completion rates reflect poor learning environments and point to the urgent need to raise teaching standards. The rapid improvement in youth literacy, from 64.1% to 80% between 2000 and 2008, appears to have reached a plateau. The Universal Basic Education Scheme, so far, is a promising initiative. The Federal Teachers' Scheme and in-service training by the National Teachers' Institute have begun to address the urgent need to improve the quality of teaching. However, to accelerate progress and reduce regional disparities, these initiatives need to be rapidly expanded and improved.

3. Promote Gender Equality and Empower Women

According to the United Nations Development Programme (2007), the ratio of boys to girls in primary education improved from 79% in 2004 to 81% in 2005 while the proportion of women in non-agricultural wage employment stood at 79% in 2005. The proportion of women in national parliament was 5.76% as against 30% target. Secondary school enrolment has increased for both males and females at the tertiary level. From the report of UNICEF (2010), female adult literacy

rate between 2003 and 2007 is 80%. A gradual improvement in the proportion of girls enrolled in primary school, though noteworthy, is not yet enough to meet the target of 2015. There are still fewer girls than boys in school. There are signs of backsliding in the number of girls in tertiary education. Measures to encourage girls to attend school, particularly by addressing cultural barriers in the north of the country, and to provide the economic incentives for boys to attend school in the southeast, are urgently required. Although few women currently hold political office, the new policy framework is encouraging. However, gradual gains in parliamentary representation for women need to be greatly expanded in forthcoming elections. Confronting regional variations in the determinants of gender inequality requires policies based on an understanding of the underlying socioeconomic, social and cultural factors. State and local government efforts will thus be critical to the achievement of this goal.

4. Reduce Child Mortality

Oshewole (2011) observes that the reduction of child mortality remains a key challenge. According to the Millennium Development Goals Report (2005), the infant mortality rate which was 91 per 1000 live births in 1990 declined to 75 in 1999 only to shoot up again to 100 in 2003. As against the global target of 30/1000 live births, in 2005, Nigeria

had 110/1000 live births. Low maternal education, low coverage of immunization, weak primary health care system, and high incidence of poverty, inequality and poor household practice accounted for high mortality rate. However, the report of the United Nations Development Programme, (2007) reveals that under five mortality rate (per 1000 live births) improved from 201 in 2003 to 197 in 2004 as against the target of 64 in 2015. According to UNICEF (2010), under five mortality rate in 2008 is given as 186. The United Nations Development Programme (2007) reports that the percentage of one-year olds fully immunized against measles rose from 31.4 in 2003 to 50.0 in 2004. Yet wide disparities subsist between rural and urban centres and among geographical zones. AFPODEV (2006) further reports that 64 per cent of births in Nigeria are classified as high risk birth. Approximately 88,400 of the 340,000 infant deaths each year representing 26% are preventable if women practice healthy fertility behaviour.

5. Improve Maternal Health

AFPODEV (2006) observes that maternal mortality also remains a daunting challenge. Nigeria has one of the highest levels of maternal mortality in the world, at approximately 1000 per 100,000 live births in the late 1990s to 2001. The United Nations Development Programme (2007) reports that against a global target of less than 75/100,000

live births in 2015; Nigeria had 800/100,000 live births in 2004. Rural areas and Northern regions are worse than the national average. About 15% and 46% of rural and urban dwellers did not go for antenatal care while about 44% deliveries were attended to by skilled health care personnel. About 2 million women of reproductive age do not survive pregnancy or child birth in 2004. UNICEF (2010) reports that women that enjoyed access to antenatal care coverage at least once, and women attended to by skilled health personnel between 2003 and 2008 were 58% and 39% respectively. The realization of this goal is made difficult by factors such as teenage pregnancy, child labour, child marriage, child disability, high cost of treatment, harmful cultural and social practices like female genital mutilation, low patronage of health infrastructures, and non-availability of health personnel especially in rural areas.

6. Combat HIV/AIDS, malaria and other diseases

Since the identification of the first HIV/AIDS case in mid 1980s, the HIV prevalence rate has continually been on the increase, from 1.8% to 5.8% between 1991 and 2001 (MDG 2005 Report). But the United Nations Development Programme (2007) reports that the HIV prevalence rate fell from 5.8% in 2001 through to 2005 to 4.4%. Prevalence across the states, however, varied significantly. Malaria and TB remain public health problems. Malaria

accounted for 60% of all outpatient attendance, 30% of all hospital admissions and 300,000 death annually. Blood transmission, unsafe injection and sexual practices are key drivers of HIV/AIDS while stigmatization and discrimination against people living with HIV/AIDS still remain rife. Poor sanitation and High cost of treatment accounted for the prevalence of malaria while poor reporting network and weak public education are responsible for the spread of TB. Striking success has been established in almost eradicating polio, reducing the number of cases by 98% between 2009 and 2010. Thus, nationally, Nigeria has already achieved this target. However, some states still have high prevalence rates that require urgent policy attention. There has been a sharp decrease in malaria prevalence rates. Nationwide distribution of 72 million long-lasting insecticide-treated bed nets, although only in its initial stages, protected twice as many children (10.9%) in 2009, compared to 2008 (5.5%). With sustained attention, tuberculosis is expected to be a limited public health burden by 2015.

7. Ensure Environmental sustainability

The country is endowed with abundant environmental resources but high population growth rate and increasing demand for these resources threaten environmental sustainability (MDG 2005 Report). The United Nations Development Programme (2007), reports

that Nigeria's rich environmental resources is undermined by deforestation (3.5% per annum), erosion, desertification, gas flare and oil pollution. Access to safe drinking water is improving. Between 2000 and 2010 the area of forest shrank by a third, from 14.4% to 9.9% of the land area. Similarly, access to safe water and sanitation is still a serious challenge for Nigeria. Little progress was made up to 2005 but improvements since then have brought the proportion of the population accessing safe water to 58.9% and the proportion accessing improved sanitation to 51.6%. In sanitation, efforts are falling short of the target, and rural-urban migration is adding to the pressure on sanitation infrastructure throughout the country.

8. Develop a Global Partnership for Development

The United Nations Development Programme (2007) reports that Nigeria has enjoyed the benefits of progressive partnership with the international community; the decision to exit the Paris Club creditors was finalized in 2005. Debt service as a percentage of exports of goods and services improved from 7.3% in 2004 to 3.4% in 2005, while foreign private investment also improved significantly. Debt relief negotiated by Nigeria in 2005 provided new opportunities for investment. Debt servicing fell from 15.2% of exports in 2005 to 0.5% in 2008. However, according to the

Millennium Development Goals Report (2005), access of Nigeria's Agricultural and Semi-processed goods to industrial countries market remains weak. Improved macroeconomic management, promoting transparent and accountable governance and substantial structural reforms are central to improved partnership. The current insecurity in the country, precisely, in Northern Nigeria has seriously affected foreign investments in Nigeria.

The challenges of the Nigerian Government in the actualization of the MDGs

The basic challenges that slow down the wheels of the Nigerian Government towards the actualization of the MDGs are corruption, terrorism and the global financial crisis.

1. **Corruption:** If there is any social malaise whose notoriety hardly can be paralleled, and which bears an ignoble identity with the geographical construction otherwise known as Nigeria, then one rarely needs a deep search to discover that which is our point of departure- corruption. Corruption enjoys an unravelled fame whose knowledge, one neither requires the dexterity of a herald nor an excruciating probe of the intellect to decipher; its ubiquity is phenomenal in all respects (Kanu, 2008); it lies beneath the façade of social cum political problems confronting the nation. It is a malaise that wears the toga of an enigma that defies a definite description, yet intimate in all fronts (Victor, 2008). The damages it has done to the continent

are astronomical. Even the mad people on the street recognize the havoc caused by corruption - the funds allocated for their welfare disappear into the thin air. Hence, it is believed by many in the society that corruption is the bane of Nigeria (Mordi and Afangide, 2002). The following are a few among the many consequences of corruption.

- Martin and Lenz (2000), argue that corruption affects economic growth as it, among other things, reduces government spending on education.
- Lipset and Lenz (cited in Kanu, 2008) opine that poverty and income inequalities are tied to corruption.
- Kanu (2008), observes that some foreign donors do not give aid to corrupt nations. For instance, the *International Monetary Fund* (IMF) has withdrawn development support from some nations that are notoriously corrupt. And the *World Bank* has introduced tougher anti-corruption standards into its lending policies to corrupt countries. Similarly, other organizations such as the *Council of Europe* and the *Organization of American States* are taking tough measures against international corruption.
- Paulo (1997), avers that corruption causes a reduction in quality of goods and services available to the public, as some companies could cut corners to reduce quality margins and increase profit margins.

- Corruption scares away investors from Africa.
- Kanu (2008), also observes that corruption is one of the reasons for the *'brain drain'* phenomenon in Africa.

2. **Terrorism:** The increasing attacks by the *Boko Harram* terrorist group in Nigeria have affected foreign investments in the country. It is a menace that has left many dead, increasing the mortality rate in Nigeria. It has rendered many people homeless and jobless as many have fled their homes and businesses, thus increasing the level of poverty in the country. It has affected the free movement of goods and services from one part of the country to another, thus declining the economic growth of the nation.

3. **Global Financial Crisis:** The global financial crisis has an effect on Nigeria's economy, mainly through lower oil revenues, the drying-up of credit and weaker flows of private capital. The crisis has underlined the need to accelerate the diversification of the economy and to strengthen fiscal management. According to the Global Monitoring Report (2010) of the IMF, due to global financial crisis, 53 million more people will fall into extreme poverty. Low-income economies, many of which are in Sub-Saharan Africa, have been buffered from the global financial crisis, with developing countries like Nigeria facing a slump in their exports, government budgets badly stretched, and foreign aid appears likely to fall short of donor promises at the very time when it will

be most needed. The crisis is having an impact on several key areas of the MDGs, including those related to hunger, child and maternal health, gender equality, access to clean water, and disease control and will continue to affect long-term development prospects well beyond 2015. Malnutrition among children and pregnant women has a multiplier effect, accounting for more than one-third of the disease burden of children under age five and over 20 percent of maternal mortality. According to World Bank projections, for the period from 2009 to the end of 2015, an estimated 1.2 million additional deaths may occur among children under five due to crisis-related causes.

The Role of the Nigerian Government in the Actualization of the MDGs

A cursory glance at the place of Nigeria in the realization of the Millennium Development Goals, reveals that although the Nigerian government has shown tremendous leadership in recent years and is putting in place programmes in an effort to realize them, she is woefully behind in achieving the MDGs.

i. Since corruption greatly affects the development of the MDGs negatively, the Nigerian Government should create more awareness, openness, accessibility and transparency around issues of corruption. This includes changing people's mindsets through positive steps such as exposing corruption when it occurs, publicizing and highlighting the problem,

including making public announcements, undertaking public campaigns and hosting anti-corruption *fora* and conferences. She needs to It is to strengthen anti-corruption bodies, the criminal justice system and the rule of law. And above all, improve on her political commitment to the people and in the fight against corruption.

ii. The Nigerian government needs to broaden the campaign for the actualization of the MDGs to include faith based organisations, labour, farmers, different capable people, women groups and other social movements.

iii. If the MDGs must be realized, the Nigerian Government needs to improve access to primary health care by providing adequate human resources for the management and provision of primary health services at all levels; adequate access to essential drugs and commodities; more investment in appropriate infrastructure, equipment and consumables. Implementation arrangements must target local needs, which vary hugely from community to community and state to state.

iv. The Nigerian Government needs to develop a more innovative Midwives Service Scheme so as to contribute substantially to ongoing shortfalls. If such a scheme is developed and expanded in proportion to the national gap in the number of midwives, this will further accelerate progress. In addition, more mothers will be covered by antenatal care as access to quality primary healthcare improves and incentives attract health workers to rural areas.

Only thus will Nigeria turn progress to date on this goal into a MDG success story.

v. The Nigerian Government needs to improve on the knowledge and awareness of HIV/AIDS, and also provide more free access to antiretroviral therapies, and effective implementation of the national strategic frameworks for HIV/AIDS, malaria and tuberculosis control.

vi. The Nigerian government needs to monitor the spending of the national budget and track resources with special attention to the achievement of the MDGs in particular and poverty eradication in general.

vii. The Nigerian government needs to increase the productivity of small farmers in unfavourable environments by focussing more and investing on them. A reliable estimate is that 70% of the world's poorest people live in rural areas and depend on agriculture.

viii. The Nigerian government needs to improve basic infrastructure, such as roads, power and communications, so as to reduce the costs of doing business and overcome geographic barriers.

ix. The Nigerian government needs to develop an industrial development policy that nurtures entrepreneurial activity and helps diversify the economy away from dependence on primary commodity exports- with an active role for small scale and medium size enterprises.

x. The Nigerian government needs to improve on the security of the country, promote democratic

governance and human rights, remove discrimination, secure social justice and promote well being of all people for the realization of the MDGs.

xi. The Nigerian government needs to ensure environmental sustainability and sound urban management and planning so that development improvements are long term.

The Nigerian Citizens and the Actualization of the MDGs

Notwithstanding the indispensable role of the government in the actualization of the MDGs, Anozie (2010) believes that in the whole process the citizens of Nigeria also have a role to play. There are about five ways the Nigerian citizen can contribute to the realization of these goals:

1. **Having a profound love for Nigeria.** According to Anozie (2010), although Nigeria as a nation has not shown much care for its people, as is evident in the corruption in the high places, death traps on our roads, poor water, poor electricity, just to mention a few, Nigerians must love Nigeria, for only it can spur Nigerians to contribute to the development of Nigeria.
2. **Respect for things Nigerian:** Kanu (2012) observes that colonialism created a lasting sense of inferiority and subjugation that builds a barrier to growth and innovation. Many Africans have lost confidence in themselves and in their abilities. This has been extended to indigenous industries; whatever comes from the African is tagged 'inferior' by other

Africans. This ranges from simple machines to simple things like clothes, furniture, bags, shoes, belts etc. Indigenous industries now prefer to tag their products 'made in USA' or 'made in China or Taiwan', giving the impression that local products are not of desirable standards. Inferiority has turned our eyes to be 'outward looking' rather than 'inward looking'. If Nigeria must actualise the MDGs, Nigerians need to begin to respect things Nigerian.

3. **Nigerians need to get involved in electoral processes**: Nigerians need to go out and vote for those they consider capable of leading Nigeria to the MDG Promised Land. The MDGs are not realization without a purposeful leadership.

4. **Preserving and keeping our environments clean**: Nigerians as individuals need to be committed in combating infectious diseases. They should be involved in holding each other accountable, as regards cutting down trees, throwing trash on roadsides, bridges or peeing or defecating on the street or in gutters (Anozie, 2010).

5. **Generosity**: We do not have to wait for the government to help those in need. We have our parts to play. Groups of friend or concerned Nigerians can join hands and raise funds to buy and donate food and clothes to children and families who are in great need. We can also form NGOs as a platform to source for funds that will aid in tackling the various MDGs or serve as government watchdogs (Anozie, 2010).

These efforts by citizens would help to complement the contribution of the government towards the actualization of the MDGs.

Evaluation and Conclusion

Abani, Igbuzor, and Moru, (2005), among others, have criticised the MDGs as risking simplifying what development is about, by restricting the goals to what is measurable, as many aspects of development cannot be easily measured. Registering his perspective, Igbuozor (2006) avers that some of the targets of the MDGs do not address some of the problems in view holistically. For instance, the MDG on education talks only of a full course of primary schooling with no reference to secondary and tertiary education; what then becomes of these levels? These shortfalls, however, does not in any way overshadow the positive sense of the MDGs. Igbuozor (2006) further observes that they draw together in a single agenda issues that require priority to address the development question, and thus have received tremendous endorsement by world's governments. The beauty of the MDGs further lies in the fact that they are few in number, indicating greater possibility of realizability; they is concentrated on human development and focused almost on a single date-2015; they adds urgency and transparency to international development and finally has attracted commitment as regards resources for her realization. As indicated by the Civil Society Consultative Forum on the Millennium Development Goals held in Abuja, Nigeria on 20th April, 2004, the MDGs provide additional entry point to engage government on development issues. The

MDGs have further provided the link between local and international actions towards human centred development. However, for these goals to turn into success stories, the governments in Africa, and indeed Nigerian government must be fully involved. This paper has tried to show how involved the Nigerian government is in the whole process, and how much has been achieved and the necessity to put in more effort for the actualization of these goals.

References

Abani, C., Igbuzor, O. and Moru, J. (2005). Attaining the Millenium Development Goals in Nigeria: Indicative Progress and a Call for Action. In Moru, J. (Ed.). *Another Nigeria is possible: Proceedings of the first Nigeria social forum.* Abuja: Nigeria Social Forum.

Adesopo, A. (2008). The poverty question and the national anti-poverty programmes in Nigeria?. In K. Ajayi (Ed.). *Public administration and public policy analysis in Nigeria* (pp. 213-227). Abuja: Panaf.

AFPODEV (2006). *Impact of population growth on the attainment of the Millennium Development Goals in Nigeria.* Abuja, Nigeria: AFRODEV.

AFRODAD (2005). *The Politics of the MDGs and Nigeria: A Critical Appraisal of the Global Partnership for Development (Goal 8).* Harare, Zimbabwe, AFRODAD.

Anozie, S. (2010). *Nigeria and the MDGs: Where we are and wow you can make a difference.* Retrieved 8/11/2012 from http://www.bellanaija.com/2010/09/22/nigeria-and-the-mdgs-where-we-are-and-how-you-can-make-a-difference.

Antrobus, P. (2003). *Presentation to the working group on the MDGs and gender equality*. Paper presented at the UNDP Caribbean Regional Millennium Development Goals Conference, Barbados, 7th – 9th July.

CGIAR (2005). *Achieving the Millennium Development Goals*. Consultative group on International Agricultural Research. Agric. Res. Matters.

Clemens, M. A., Kenny, C. J. and Moss, T. J. (2007). The trouble with the MDGs: Confronting expectations of aid and development success. *World Development 35*. 5, 735-751.

Easterly, W. R. (2006). *The White man's burden: Why the West's efforts to aid the rest have done so much ill and so little good*. Oxford: Oxford University.

Eyben, R. (2006). The road not taken: International aid's choice of Copenhagen over Beijing. *Third World Quarterly. 27*. 4, 595-608.

Fukuda-Parr, S. (2008). *Are the MDGs priority in development strategies and aid programmes? Only few are!* Brasilia: UNDP.

Hall, S. (2005). *African fisheries and aquaculture and the Millennium Development Goals*. In the Proceedings of the NEPAD-Fish for All Summit, Abuja, Nigeria, pp: 44-48.

Hulme, D. (2009). *Millennium Development Goals (MDGS): A Short history of the world's biggest promise*. Manchester: Manchester University.

Kanu, I. A. (2008). Corruption in Africa and its implications for the enterprise of Christian theology. A paper presented at the 20th National Conference of the National Association of Catholic Theology Students

(NACATHS), held at All Saints Major Seminary, Ekpoma, Edo State March 10th -15th.

Kanu. I. A. (2012). The colonial legacy: The hidden history of Africa's present crisis". *International Journal of Arts and Humanities, 1. 1,* 123-131.

Kingdom, T. & Alfred-Ockiya, J. F. (2009). Achieving the Millennium Development Goals through fisheries in Bayelsa State, Niger Delta, Nigeria. *Asian Journal of Agricultural Sciences 1. 2,* 43-47.

Martin, L, & Lenz, G. (2000). *Corruption, Culture, and Markets, in Culture Matters,* In Lawrence E. H. & Samuel P. H. (Eds). New York: Basic Books.

Paolo, M. (1997). Why worry about corruption? *Economic Issues, 6,* 10.

Mordi C, & Afangide F. (2002). Corruption: Nigeria's Existential question. *The Quest. 2. 2.* 21-22.

Nigeria Millennium Development Goals Report (2005). Government of the Federal Republic of Nigeria.

Nigeria Millennium Development Goals Report (2010). Government of the Federal Republic of Nigeria.

Okonjo-Iweala, N. Soludo, C. C., Muhtar, M. (2003). Introduction. In N. Okonjo-Iweala, C. C. Soludo, M. Muhtar (Eds.). *The Debt Trap in Nigeria: Towards a Sustainable Debt Strategy* (pp. 1-19). Trenton: Africa World.

Omotola, J. S. (2008). Combating poverty for sustainable human development in Nigeria: The continuing struggle. *Journal of Poverty, 12. 4,* 496-517

Ortive Igbuzor (2006). *Review Of Nigeria Millennium Development Goals - 2005 Report.* A review presented at the MDG/GCAP Nigeria planning meeting held in Abuja, Nigeria on 9th march, 2006.

Oshewole, (2011). Poverty reduction and the attainment of the MDGs in Nigeria: problems and prospects. *International Journal of Politics and Good Governance. 2, 2. 3*, 1-22.

Ovwasa, O. L. (2000). Constraints on poverty alleviation in Nigeria. *Political Science Review: Official Journal of the Department of Political Science, University of Ilorin, Nigeria, 1.1,* 56-80.

Sachs, J. D. (2005). *The end of poverty: Economic possibilities for our time.* New York: Penguin.

Soludo, C. C. (2003). Debt, poverty and inequality: Toward an exit strategy for Nigeria and Africa. In N. Okonjo-Iweala, C. C. Soludo, and M. Muhtar (Eds.). *The debt trap in Nigeria: Towards a sustainable debt strategy* (pp. 23-74). Trenton: Africa World.

UNDP (2003). *Millenium Development Goals: A Compact among Nations to end Human Poverty.* New York: Oxford University.

UNDP (2007). *MDGs in Nigeria: Current progress.* Retrieved 10/11/2012 from: http://web.ng.undp.org/mdgsngprogress.shtml

UNICEF (2010). *At a glance: Nigeria.* Retrieved 10/11/2012 from: http://www.unicef.org/mdg/index_aboutthegoals.htm

UNICEF (2012). *Millennium Development Goals.* Retrieved 8/11/2012 from http://www.unicef.org/mdg/index_aboutthegoals.htm

Victor E. D. (2008). *Corruption in Nigeria: A New Paradigm for Effective Control.* Retrieved 20th August 2008. www.AfricaEconomicAnalysis.org.

Wikipedia (2012). *Millennium Development Goals*. Retrieved 8/11/12 from http://en.wikipedia.org/wiki/Millennium_Development_Goals

World Bank (2001). *World Development Report 2000/2001: Attacking poverty*. N.Y: Oxford University.

SLAVE TRADE AND THE SOCIO-POLITICAL ECONOMY OF AFRICA

Introduction

The 18th century produced significant philosophers of exciting lives and ideas. To these, Jean Jacque Rousseau (1712-78) was not an exception. He was one of those who epitomized the greatest turning points in the history of Western thought. He is popular for his essay on *The Social Contract*. However, in his prized essay of 1754 on *The Origin of Inequality among Men and Whether it is Legitimated by the Natural Law*, he explained the origin of the inequality of species. He begins by analyzing the equality of men which he ascribes to the condition of man in the pre-existence state. Inequality among men, he argued came about as a result of leaving the state of nature, which he called an original sin, in which man ate the forbidden fruit, that is, the fruit of the emergence of the hunger for private property. The first man who fenced in an area and called it his and found people simple enough to believe him, is the originator of the civil society (Dahrendorf, 1970).

With this development, man arrived the land of inequality, of oppression and exploitation; the only language appreciated was that of Protagoras: "man is the measure of all things". He designs the structure of the world to enhance his personal goals. To achieve his objectives he degraded the dignity of others. Hunger for wealth blinded man to the truth that to possess a little in an honourable way, is better than to posses much through injustice. As a consequence of this evolution of the human society, Jean Jacque Rousseau said that "Man is born free but he is everywhere in chains". This statement is true of the African who was born free like any other human being in the world, but found himself under the chains of slavery. This piece is centred on the infamous Trans-Atlantic Slave Trade and its consequences on Africa even after over a hundred and sixty years.

Africa's Experience of the Slave Trade

Slave trade was already in Africa before the advent of the Arabs and subsequently the Europeans. Africa had so many lands, and to meet up with desired production rate, families bought slaves to help out; these slaves were well incorporated into the family so that the second or third generations of slaves were seen as members of the family. They could marry, have kids and even possess property and could not be killed without a genuine reason. They were fed, sheltered and protected. Sometimes they occupied chief positions in the society, especially when the slave proves to have managerial ability or military skills, he could be raised to the level of caretaker of his master's household. Female slaves could also become wives to royals and thus their descendants became royals as well.

Before the European Trans-Atlantic Slave Trade, the Arabs were already engaged in the purchase of slaves, which were transported through the Sahara to North Africa and Arabia. This was the Trans-Sahara Trade, principally between North Africa and the empires of Sudan. With the conversion of North Africa to Islam, and with the Islamic law forbidding Muslims from enslaving other Muslims, Africans South of the Sahara became victims. In the Sudanese state, the Muslims enslaved the non-Muslims, whom they regarded as pagans. Most of them ended as domestic slaves in North Africa and Arabia. The misery of these slaves were enormous, especially as they had to walk across the desert with little food and water, and sometimes carrying their master's goods. As a result, many died.

By the end of 16th century, the Trans-Sahara slave trade declined, basically because of the Trans-Atlantic slave trade which was beginning to shift attention from the desert to the coasts. The European slave trade was more sophisticated than that of the Arabs. The Arabs were primarily concerned with the selling of slaves to Arab buyers who used slaves for domestic purposes. Whatever, the intensity of the Arab slave trade, its consequences are not "matchable" with the massive, involuntary movement of people out of western and west central Africa between 1440 and 1880.

In about the middle of the 15th century, with the dawn of the Industrial Revolution in the Western hemisphere, the European expanding empires lacked manpower to work on new plantations that produced sugar cane for Europe, and other products such as coffee, cocoa, rice, indigo, tobacco,

and cotton. This is because, on the one hand, the native Americans who were enslaved by the Europeans proved unfit as a result of the ingenious tropical diseases that they suffered, diseases like smallpox, mumps, and measles, which the Europeans introduced into the region and to which the Native Americans lacked immunity. Africans, on the other hand, were excellent workers: they often had experience of agriculture and keeping cattle, they were used to a tropical climate, resistant to tropical diseases, and they could work very hard on plantations or in mines, and so the Atlantic slave trade became an integral part of an international trading system which was then guarded by international laws. Thus, Africans became the best economic solution for plantation owners seeking inexpensive labour.

The Trans-Atlantic slave trade involved the largest intercontinental migration of people in world history prior to the 20th century as millions were severed from their homelands. This period of carnage went on for about five hundred years during which an estimate of 12 million viable Africans were taken from their home lands to locations around the Atlantic, and about 10 million were able to reach the desired destination. The vast majority went to Brazil, the Caribbean, and other Spanish-speaking regions of South America and Central America. Smaller numbers were taken to Atlantic islands, continental Europe, and English-speaking areas of the North American mainland. The Portuguese began the Trans-Atlantic Slave Trade in 1441, and for about 200 years they dominated in this trade. Ashun (2004) avers that it all began when Atam Goncalves, an explorer of Prince Henry of Portugal, captured 10 African

men from Senegambia to serve as a proof that the Portuguese had finally reached the black man's land and found people truly living there. Since then, Europeans began the tradition of returning with African captives. It is such that as far back as 1454, before the building of the Elmina Castle, about 250 Africans were taken to Spain every year. In 1518, Emperor Charles V of Spain authorized the shipment of 15,000 Africans to Santo Domingo to work on the plantations. This marked the beginning of the unfortunate story of the Trans-Atlantic Slave Trade.

The Portuguese were not long after joined by the Spanish, French, Dutch, after 1560 the English also joined in the trade and merchants from Liverpool were not exempted. As you can see, it was a big trade and of huge interest, at least from the fact that it brought the world powers to Africa (Gimba, 2006). It is estimated that during the five centuries of the Trans-Atlantic slave trade, Portugal was responsible for transporting over 4.5 million Africans, which is about 40% of the total. During the 18^{th} century, however, when the slave trade accounted for the transport of a staggering 6 million Africans, Britain was the worst transgressor - responsible for almost 2.5 million.

The Capture and Transportation of Slaves to Europe

In 1500 a new culture developed in Europe that required Negroes as domestic workers. So the Portuguese bought slaves in Africa to supply this small scale demand. However, with the discovery of the West Indies by Christopher

Columbus and development of plantations in Brazil which was then a colony of Portugal, and with the development of sugar, tobacco and cotton plantations in European colonies like in North America, silver and gold mines, the demand for slaves grew rapidly.

The European slave merchants had different ways of getting at their victims. Sometimes, the Europeans captured Africans themselves, sometimes too, they collaborated with Africans to capture Africans, and at other times, African slave raiders captured Africans and sold them to African merchants, who in turn sold them to the Europeans. However, at the start, the innocent victims were invaded and captured along the coasts and taken abroad. By this time, the slave trade began to be increasingly important than trade in gold, ivory, and other produce. According to the earliest records of slave trade kept by Azurara, leader of a Portuguese venture in 1446, after the ship had landed on the West Central Coast of Africa, soldiers swamped ashore, ceased a few curious victims and unsuspecting natives and proceeded inland seeking more victims (Gimba, 2006). There were also times when they failed in such raids. Abraham (1962) has one of the graphic descriptions of such raids:

> Alonzo Gonzales, the Portuguese, was the first man to point out Africans to his countrymen as articles of commerce in 1434. In 1440 having kidnapped 12 Africans, he put a woman among them on the shore in the hope that her people would come forward to redeem her. Next day, some hundred and fifty appeared. The Portuguese did not feel venturesome

on that day, and they were handsomely treated to a volley of stones (p.118).

Such confrontations demonstrated Africa's strength, and it then became obvious to the Europeans that the only practical way to get slaves were to bring commodities to African chieftains for exchange with slaves.

However, from about the 18th to the end of the 19th century, slaves were obtained from along the west coast of Africa with the full and active co-operation of African kings and merchants. Wars were very important at this time. During wars prisoners of war were gotten and conquered territories were forced to pay annual tribute of slaves, and if they conquered territory can't pay, she has to conquer another weaker tribe and force her to pay her tribute. Wars were common between states like Oyo and other Yoruba states. Normal life was indeed disrupted in many places in Africa (African encyclopedia for Schools and Colleges, 1974). Relations were entered into with many of the African states like Benin kingdom in Nigeria and also with Congo. The Europeans on their visits expressed all manners of friendship and liberalism, they brought presents and peaceful deportments and messages from their king. Sometimes they put on the garb of missionaries, of which in the true sense many of them were not, most were concerned with the economic value of the African rather than with the salvific value of his soul. For instance, in the Congo, they first came as missionaries, and Afonso the king of Congo thought that he had found a confidant in the king of Portugal, only to be gravely disappointed when his subjects were forcefully

carried away as salves. He became so helpless watching his crying subjects taken to the Gold mines in the Gold Coast or across the ocean to Portugal resulting in the depopulation of his kingdom (Dagin, 2007).

Trade in slaves was booming, so much that the whole of the administration of the coastal region of West Africa, from the Senegal River down to Angola, were popular for their supply of slaves (The Spectrum Encyclopdeia of Africa, 1976). When these slaves were caught, they were tied and chained, and then made to walk long distances of about 1,000 miles to the European coastal forts. The match was so tedious that, only about half of the slaves made it to the ports. They were underfed, shackled, and those who were sick were either killed or allowed to die, and those who made it to the forts were kept in dungeons for months before the arrival of the boarding ship, and then they were packed like goods. Very notable of these dungeons is the Elmina Castle. Here, they were maltreated, packed together in unhealthy conditions, the women were raped by the whites since they did not come along with their wives. Captives were held at the dungeons for about one or two months, depending on when the ship comes.

In return for the slaves, African kings and merchants received various trade goods in exchange including beads, cowries shells, European manufactured goods, textiles, hardware, liquor, horses, and perhaps most importantly, firearms. The price of a Negro was one Birmingham gun. In places like the New Calabar, between 1703-1704, the price for a slave in the Slave Market was 12 bars of iron for

a male and 9 bars of iron for a female. The guns were used to help expand empires and obtain more slaves, until they were finally used against the European colonizers. Since the African sold their fellows to the Europeans, the Europeans saw slavery as being justified since they argued in the 17th and 18th centuries that if the Africans had the right to sell their own children, the Europeans certainly had the right to buy them (Abraham, 1962). Here we find a true scenario in which the unsupported efforts of piety, morality and justice were weak against interest, violence and oppression.

Slave masters, especially from colonial American slave ship were known to hypnotize the African merchants with alcohol (rum) before they began bargaining. On the arrival of the European slave merchants, they spread the taste for liquor on the coast, and negro traders drank until they lost their reason and then the bargain was struck. At other times they even enslaved African slave merchants after bargain. An African slave dealer during bargain was reported to have been invited to a dinner by the slave ship captain, and just after the captain had paid the African for his slaves, in the ship, the captain seized his bag of gold and consummated the process by enslaving the guest (Gimba, 2006). On board, the men bought as slaves were chained to guard against revolt. The usually fewer women and children were freer. They were fed twice a day, and the quality and quantity varied pending on purchases done before departure. Corn and rice from the less-forested regions on the northern and southern extremes; yams from the Niger Delta to the Zaire River. Sometimes dried beans from Europe were standard fare. Each person received about a pint of water with a

meal (Encarta Encyclopedia, 2004). Since the slaves were regarded as goods rather than human beings, when the ship was at risk of sinking, the goods (African slaves) were thrown into the sea to balance the movement of the ship.

Slaves were introduced to new diseases and suffered from malnutrition long before they reached the new world. It is suggested that the majority of deaths on the voyage across the Atlantic - the middle passage - occurred during the first couple of weeks and were a result of malnutrition and disease encountered during the forced marches and subsequent interment at slave camps on the coast. The enslaved African was quite unlike the native Indian in that the African was taken away from his native homeland to where he was completely deprived of the aperture to interact with his people as well as the ability of his social organization (Gimba, 2006). While the American slave could hide from his exploiters because of his knowledge of the land, the Africa found himself lost in the whole terrain.

The slaves that were sent down to Europe came by various means. Some of the slaves were the mentally ill. Criminals were also disposed as slaves; this took the place of capital punishment. Heretics and those who fell out of favour with the ruling authorities were also sold as slaves. However, almost half of the total of slaves came through military conquests of other states or communities. For the Atlantic slave trade, captives were purchased from slave dealers in West African regions. Some African kings sold their captives locally and later to European slave traders for goods such as metal cookware, rum, livestock, and seed grain. Previous

to the voyage, the victims were held in "slave castles" and deep pits where many died from multiple illnesses and malnutrition; some killed themselves.

The Triangular Nature of the Slave Trade

The result of slavery in Africa was a triangular movement of trade, where by England, France and Colonial America supplied the exports and ships and Africa, the human merchandise. The African slaves were moved to the coast and then taken to plantations in Europe where they worked for the provision of goods like sugar, cotton, rubber and other tropical products and these same goods were brought over to Africa and again exchanged with slaves. While the ships sailed with cargos of manufactured goods they were returned filled with slaves who were treated as cargos. This triangular trade gave a triple stimulus to European industries, and created new ones.

The export of trade goods by slave traders from European ports to African ports forms the first side of the triangular trade. The transport of slaves from Africa across to the Americas forms the middle passage of the triangular trade. This leg was horrifying for the slaves, and it is estimated that the slave traders made about 54, 000 turns to Africa when they picked with them millions of viable Africans as slaves. This journey usually lasted for months, sometimes a year before arrival to the European ports, pending on the origin, the destination and the winds. The third, and final, leg of the triangular trade involved the return to Europe with the produce from the slave-labour plantations: cotton, sugar, tobacco, molasses and rum.

The Condition of the Slaves in Europe

The condition of the slaves in Europe varied pending on the charity of the master. Some masters relatively took good care of their slaves. Other owners treated them as animals and sometimes even less than animals. In places like Brazil, the slaves were kept together and allowed to continue their traditional beliefs. In some other places they were deliberately separated to prevent them from uniting against their masters. Yet, this did not stop slave revolt as records have about 250 of such revolts in America (African Encyclopedia for Schools and Colleges, 1974).

The slaves moved over to Europe were slaves for life, and their children were also destined to slavery. Hard work and torture reduced the life-span of the slave, so that throughout America the life span of the slave was estimated at seven years. They worked like animals usually under the supervision of their taskmasters who kept them alert with whips: between 50 and 200 strokes were the penalties for the least negligence. To be a slave was to be a beaten body. Laennec Hurben describes the unfortunate condition of the slave and the uncivil attitude of the civilized masters thus: "For the master had to work rigorously- for the degradation of the slaves, for their complete and utter downfall so as better to reduce them to what was considered to be their natural condition" (Hurbon 1990, p.94). While working on sugar cane plantations, when the slaves were caught sucking sugar cane, their masters went to the root of the matter by breaking their teeth so that they wouldn't suck any more.

The story of a rebellious or lazy slave is more pitiful. According to Hurbon (1990):

> The tortures reserved for the rebellious and lazy slave are not evidence of a particular cruelty of some masters, but are part of the structure of the daily practice of slavery. To apply a red-hot iron to the tender parts of the slave, to tie him to stakes so that insects gnawed him to death, to burn him alive, to chain him, set dogs or snakes at his heals, to rape negresses, and many such tortures served above all to express absolute domination. And it was absolute, or rather it claimed to be: in the act of branding slaves, changing their names, mixing the races, making them lose all kinship, in short producing among them a cultural amnesia from which they emerged zombies, living dead totally subjected to the caprices and humours of their masters. (p. 94).

Whipping, branding, dismembering, castrating, or killing a slave was legal under many circumstances. Freedom of movement, to assemble at a funeral, to earn money, even to learn to read and write, became outlawed. Their clothing, feeding and housing where at the liberty of their slave masters who usually carried them out with extreme unwillingness. According to Dutertre, the adult slaves had a few rags as clothing while the children were naked, without the 'privilege' of a rag; this was in line with the condition of the slave that was supposed to be made visible until death. And when the slave dies, he was buried like an animal, either with his rags or wrapped with some canna leaves (Hurbon 1990). This was

the reward for his labour. His situation was so poor that for him, all that pleased him was Sunday, on which he did not work, and sleep, during which he did no work.

The Abolition of Slavery

The abolition of slavery in Africa was not born out of humanitarian motives or feelings as such, it was capitally as a result of the revolt of the slaves themselves and more for economic reasons. For instance in France, On 27 April 1848 Victor Schoelcher, the French under-secretary of state for the colonies, signed a decree abolishing slavery, because of the danger of a general uprising of slaves. Under the economic argument central to the 18th and 19th centuries: first it was argued that people did not work effectively under the conditions of slavery. Secondly, the wars in places like among the Yorubas, and devastations caused by slave raidings was making trade very difficult and dangerous in many parts of Africa (African Encyclopedia for Schools and Colleges, 1974). Thirdly, the number of slaves was growing and this was a threat to the European population. Fourthly, new technologies were coming up. Machines for work on plantations were now coming into the market, and they were cheaper and faster than the African slave.

Before the formal abolition of slavery, the slaves had begun to sing their freedom which they expressed in different colours. They sang this song primarily in two ways: either by leaving their bodies to their masters to rejoin Africa symbolically or spiritually: suicide, the refusal of care or food and infanticide. As an alternative, they ran away from

their masters individually or collectively marooning about. Hurbon (1990) writes:

> Rumours of poisoning, revolts accompanied by burning of the plantations and sugar factories, haunted the sleep of their masters throughout the 18th century. Soon, in the wake of the French Revolution, St Dominique, France's most popular colony, with more than 400, 000 slaves, offered the spectacle of the first major successful slave revolt. An insurrection sparked off during the night of 15th August 1791, was the inauguration of a long struggle lasting 13 years. (p. 97).

From the account in William Byrd's diary, expressions of theses struggles emerged. "On the 9th of September last at Night a great Number of Negroes Arose in Rebellion, broke open a Store where they got arms, killed twenty one White Persons, and were marching the next morning in a Daring manner out of the Province, killing all they met and burning several Houses as they passed along the Road" (William, 2005). An African man named Jemmy, thought to be of Angolan origin, also led a march from Stono near Charleston toward Florida. Other slaves joined Jemmy and their numbers grew to nearly 100. Jemmy and his companions killed dozens of whites on their way, in what became known as the Stono Rebellion. White colonists caught up with the rebels and executed those whom they managed to capture. The severed heads of the rebels were left on mile posts on the side of the road as a warning to others. White fear of blacks was also rampant in New

York City. In 1741, fires were ignited all over New York, including one at the governor's mansion. In witch-hunt fashion, 160 blacks and at least a dozen working class whites were accused of conspiring against the City of New York. Thirty-one Africans were killed; 13 were burned at the stake. Four whites were hung (Obadina, 2005).

France was the first European country to abolish slave-trade in the late 18th century in 1794. It was revisited by Napoleon in 1802, and was banned for good in 1848. In 1807 the British Parliament passed the "Abolition of the Slave Trade Act", under which captains of slave ships could be fined for each slave transported. This was later superseded by the 1833 Slavery Abolition Act, which freed all slaves in the British Empire. Abolition was then extended to the rest of Europe. In 1818-1825, similar laws were passed in places like Brazil, Portugal, Spain (African Encyclopedia for Schools and Colleges, 1974). Prominent figures on the fore of the move for the abolition of slave trade were David Livingstone whose reports helped in accelerating the ending of Slavery; Wilberforce a member of the British parliament, Lincoln, a one time US president. However, all these abolitions came only after there were enough slaves across the Atlantic for agricultural and domestic purposes. The parts of Africa whose income depended largely on the slave trade did not want this, and as such continued in the trade. British ships watched the coastal areas to hinder illegal slave trading, and this became part of the reasons for British extension of her colonization of Africa. However, many Africans remained in many parts of Europe and have contributed to the development of the areas.

The Consequences of the Trans-Atlantic Slave Trade on Africa

The late Afro-American civil rights leader Martin Luther King said that only very few people realize the extent that slavery had scarred the soul and wounded the spirit of the black man. In Africa, the many places that suffered from slave-raiding passed through the re-moulding of many years before recovery from the experience. Places in Africa that depended largely on slave trade found it difficult to discover other areas of economic importance. This period of carnage began at a time when Africa was at an agricultural stage of civilization. Ashun (2004) avers that this was the origin of periodic famine in Africa. With the tensions created by slavery all the dreams that lied laid ahead were destroyed (Gimba, 2006). Local industries were destroyed and the independence of Africa crushed. They further introduced tobacco, alcohol, guns and gun powers to keep us drunk and busy fighting while they catered away with our resources. Many Africans died from tobacco and rum, and many were lost in wars intensified by the imported guns.

Consequential to the several raidings, many people ran away from their communities and went into hiding in remote and easily defended highland areas for protection, which of course affected the peace and course of development of the people. However, with the abolition of slavery, those who took refuge in places outside their habitats began to make their ways to more habitable areas. This left deep sentiments of hostility in some areas; for instance between the Southern and Northern parts of Sudan. People feel that they have

been abused and disregarded by others. The sentiments of hostility are enormous that till date, it is very difficult to preserve the unity of the country (Gimba, 2006).

The wars that were waged between communities so as to procure slaves were intensely destructive, and had its consequences. There was a growth in insecurity, and increased uncertainty of life gave added force to superstitious beliefs and customs. People sought salvation and protection from the spiritual world. They paid homage to gods to safeguard themselves and their families from misfortune. It was great so that distrust was a basic requirement for individual and communal survival. All these have their hands on Africa's underdevelopment. Wherever there is no peace and stability, there can't be development.

The psychological impact of the dehumanizing trade was crippling as so many Africans believed that the whites took the slaves away to be eaten as food. There was constant anxiety caused by perpetual fear of being captured and herded away like common animals to a place of no return (Obadina, 2005). It profoundly changed the racial, social, economic, and cultural make-up in many of the American nations that imported slaves. It also left a legacy of racism which many African nations are still struggling to overcome. According to Karenga (2005), the morally monstrous destruction of human possibility involved redefining African humanity to the world, poisoning past, present and future relations with others who only know us through this stereotyping and thus damaging the truly human relations among peoples.

The loss in human resources had dire consequences for labour dependent agricultural economies. Population has contributed to the socio-economic development of many European countries, say in the areas of providing labour, markets. Even in China and parts of Asia, the contribution of population to economic development cannot be overemphasized. And of course African people were conscious of the relevance of population to economic development. For instance among the Balanta in Guinea Bissau, it was believed that the family's strength lies in the number o hands to cultivate the land, among the Shambala of Tanzania, like expressions are obtainable, "a king is people" (Walter 1976, p.106). The predominance of the slave trade prevented the emergence of business classes that could have spearheaded the internal exploitation of the resources of their societies. The slave trade drew African societies into the international economy but as fodder for western economic development. This experience has left Africa permanently disadvantaged when compared to other parts of the world, and largely explains that continent's continued poverty.

After the abolition of slavery, freed slaves went back to Africa. In 1782, Sierra Leone was founded by the British people as a settlement for the slaves from Britain. In 1849, Libreville which means Freetown in French, now the capital of Gabon was founded for free slaves from France. In 1822, released slaves form USA were also settled in Liberia. Till date, location destabilization or their historical (from Africa to Europe and from Europe to Africa) unstable nature of settlement has affected their development. Their situation finds expression in the view of Cheik Ante Diop, who was

a black American who remained abroad after the brutal slave trade. He said that when people always move around they cannot create culture. Permanent location is a mighty element of civilization. When the African freed slaves were pushed back to Africa they began again from the savage state when men roamed about having no continued abiding place (Gimba, 2006).

Conclusion

The foregoing has studied the event of the Trans-Atlantic Slave Trade in Africa and its consequences. It has discovered that the 19th century was one in which the shadow of the Trans-Atlantic Slave Trade overshadowed every aspect of life in Africa. The consequences are numerous: the cheapening of human life, fundamental insecurity, disintegration of social bonds and the constraint on productivity. The consequences are still telling on Africa. Many of the freed slaves who remained in Europe became poor peasants, working as household workers and migrant workers, unemployed and living in shanty areas and still victims of racism. The task of eradicating racism in all its ramifications is a dream that still remains unrealized. It is a dream which must be regarded as part of the duty of the human race in the midst of many contemporary human struggles. I would like to end this paper with a tribute I saw at Elmina castle, Cape Coast, Ghana 2013: "In everlasting memory o the anguish of our ancestors. May those who died rest in peace. May those who return find their root. May humanity never again perpetrate such injustice against humanity. We the living vow to uphold this".

References

Ashun, A. (2004). Elmina, the Castle and the Slave Trade. Cape Coast: Nyakod.

Dahrendorf, R. (1970). *On the origin of inequality among men*, in Social Inequality, England: Pengium.

Stumf, S. E. (2005), *Philosophy, History and Problems*. London: MC Graw Hill.

Gimba, D. (2006), Lecture Note on *African Traditional Society*, Theology I, St Augustine's Major Seminary.

Abraham, W. E. (1962). *The Mind of Africa*. London: Weidenfeld and Nicolson.

Dagin, S. (2007), *Notes on African Church History*, Theology II, St Augustine's Major Seminary, Jos, 2007.

The Spectrum Encyclopedia of Africa (1976), *The Beginning of Slave Trade*. Nigeria: Spectrum Books.

African Encyclopedia for Schools and Colleges (1974). *Slave Trade*. Oxford University Press.

Omoregbe, J. (1997), *A Simplified History of Western Philosophy: Ancient and Medieval Philosophy*. Lagos: Joja Press.

Encarta Encyclopedia (2004). *Atlantic Slave Trade,*. © 1993-2003 Microsoft Corporation.

Hurbon, L. (1990), *The Slave Trade and Black Slavery in America*. In Leonardo B, Virgil E. (Ed.). Concillium (pp. 1492-1992). London, SCM Press.

William Byrd's diary (2005). Retrieved November, 2005. http://www.pbs.org/wgbh/aia/part1/1h283.html.

Obadina, T. (2005), *Slave trade: a root of contemporary African Crisis*. Retrieved November, 2005. http://en.wikipedia.org/wiki/African_slave_trade.

Karenga, M. (2005). Retrieved November, 2005. HYPERLINK http://en.wikipedia.org/wiki/African_slave_trade.

COLONIALISM AND THE SOCIO-POLITICAL ECONOMY OF AFRICA

Introduction

October 12, 2011 marked the 519th anniversary of what the historian Kirkpatrick Sale calls the beginning of "the European conquest of the world" (Kirkpatrick quoted in Feliz, 1998). It was a time when Christopher Columbus, the middle aged Italian Sailor, an admiral of the ocean sea, and a one-time colonial governor whose haphazard voyage across the Atlantic set in motion the Colonial Era. Driven by a frenzied greed, which found expression in his hunger for gold, Christopher Columbus set the stage on the Island of Hispaniola (now Haiti and the Dominican Republic) where he forced the Island's inhabitants to bring him a 'hawk's bell' full of gold. Those who failed to meet his demands had their hands hacked off, or were murdered outright (Koning, 1991).

Bartolome de Las Casas, a Catholic priest wrote his famous *Brief History of the Destruction of the Indies,* in which he

graphically described the depredations of the European fortune seekers. He said that they hurled themselves on the Indians 'like wolves after days of starvation' (Bartolome quoted in Felix 1991). The cries of the Indian nations capture the terror of the times:

> Great was the stench of the dead…. After our fathers and grand fathers succumbed, half of the people fled to the fields. The dogs and the vultures devoured the bodies. The mortality was terrible. Your grand fathers died, and with them died the son of the king and his brothers and kinsmen… oh, my sons! We were born to die! (Woodward 1985, p.8)

This is a history that has not left the Indian Americans, as their natural wealth has been plundered, their wild life exterminated, the land, air and water poisoned. Since 1942, more than 140 of their animals and bird species have become extinct. Its memory carries with it a feeling of nostalgia. Profit has come before people!

These notwithstanding, during the 19th C, the scramble for territories by the European powers took a new turn as they began to make significant advances into tropical Africa. By 1913, European powers had divided the African continent into a patchwork that showed little regard for ethnic and linguistic boundaries. In this piece, it is the primary concern of the researcher to show how the hidden history of colonialism still looms at the horizons of Africa's present crisis (Hodder, 1978).

The Concept 'Colonialism'

Colonialism ordinarily denotes a situation in which one political entity exercises direct political and economic control over a part of the world not contiguous to it, or a movement or set of ideas designed to bring about or justify such a relationship. The historical prototype from which the phenomenon of colonialism gets its name is the practice of the Greek City States of sending excess population abroad to areas where new city states composed of Greek inhabitants were established, largely independent of the mother city. Modern colonialism differs fundamentally from its Greek prototype; it is an aspect of the expansion of European civilization and political power over the whole world that began in the 15th century and had since assumed a variety of forms (Ferkiss, 1987).

The Motives for Colonialism

Motivations for colonialism varies with the particular colonial power involved and the periods in history in which the colonization took place.

Originally, the motivation was largely economic, springing from the desire – especially strong in the Iberian powers to find the sources of the precious metals (gold etc.,) that the prevailing mercantilism made the basis of economic strength, the desire to acquire trading stations, and the desire for plantations that could produce certain kinds of agricultural products without the loss of foreign exchange. This was the primary motivation of Hernando Cartes, a

victim of pseudologia and one of the Spaniard *conquistadors* who followed Columbus, when he made a demand on the American Indians:

> Send me some of it, because I and my companions suffer from a disease of the heart which can be cured only with gold (Turner 1983, p.8).

This is an apt description of the spiritual vacuum and economic greed that centered the European soul.

Closely linked with economic motives were religious motivations: the 19th C missionary zeal for spreading the true faith among the heathens.

Considerations of political power loomed largely as motive for acquiring colonies. Colonies were areas where surplus populations loyal to the mother nation could allegedly flourish, forming a man power reserve; colonies were a source of national prestige; they were important elements in international strategic planning, and colonial expansion played a part in maintaining the delicate European balance of power (Ferkiss, 1987). These notwithstanding, the British expansion in Africa during the 19th C was partly occasioned by the humanitarian motive of suppressing the slave trade.

The Colonization of Africa

Before 1830, European settlements were for the most part restricted to small coastal trading stations. Both physical and economic factors combined to retard penetration.

Once having landed on the coast, penetration inland was discouraged by varied physiographical features. Economically, it did not seem to them that there were any valuable mineral to be found inland – a contrast with South America where the search for gold and silver led the Spaniards to some of the most inaccessible parts of the continent (Mountjoy & Embleton, 1966).

But during the mid 19th C, European explorers began to make significant advances into tropical Africa. First among these included Mungo Park, Clapperton and Lander – all in West Africa- and during the middle years of the 19th C exploration extended further inland and included the great trans-Saharan Sudanic journeys of Barth. Meanwhile between 1841 and 1863 the likes of Livingstone and Grant increased Europe's knowledge of and interest in the east and south-east of the continent. This opened up the Congo to European influence- an influence which, it was hoped would open a path for commerce and Christianity to destroy what the whites and their missionaries considered the evils of African society and the Arab slave trade. As a result of these and numerous other explorations and journeys, too, many of the great puzzles of African geography for Europeans – notably the course of the Nile, Niger, Congo and Zambezi rivers – were solved within the space of half a century (Hodder, 1978).

Since explorers came from several different European countries – Spain, Portugal, France, Britain, Belgium and Germany – Africa soon became a field for the conflicting ambitions of the major European colonial powers. By the

early 1880's these conflicting ambitions were beginning to be expressed territorially. Sections of the coast were being claimed by traders and administrators of one or other of the European powers. Missionary, trading, military and administrative activities were beginning to expand. The stage was now set for the European scramble for Africa, finally to be set in motion by the 1884-5 Conference and Treaty of Berlin. This laid down that European colonial claim to territory could only be secured by what was termed 'effective occupation'; in other words, European powers with interests on the African coast to move inland to secure their hinterlands. The subsequent scramble for territory by European powers took place so rapidly that within a decade the outlines of most of the colonial territories- and, significantly, of most of the present independent African states – were laid down (Hodder, 1978). As pointed out earlier, it was so rapid that by 1913, European powers had divided the African continent into a patchwork that showed little regard for ethnic and linguistic boundaries.

The Colonial Legacy and Africa's Present Crisis

The significance of recent changes in Africa, be it economic, political or otherwise, can only be assessed in the perspective of history. It is true that the colonialists helped in the development of Africa, but these developments were versely disproportionate to how much African resources and man power contributed to the development of Europe. In fact these developments were indeed the fruits of African labour and resources for the most part. Rodney Walter brought this to bear when he said in his famous book *How*

Europe Underdeveloped Africa, that 'What was called the development of Africa by the colonialists was a cynical shorthand expression for the intensification of colonial exploitation of Africa to develop capitalist Europe' (Walter, 1978, p.244).

The European culture of the late 19th C introduced racism and social Darwinism in Africa. The elevation of the white race above blacks had lasting repercussions in lands with significant European immigration, notably South Africa and Rhodesia. Even more damaging was the inauguration of the idea that the Northern Hamates such as the Ethiopians and Tutsi's were racially superior to other Africans. This division of society into rival ethnicities has had long-lasting negative influence, especially in places like Rwanda and Burundi. The 1994 genocide in Rwanda was an offspring of such mentality, where the Tutsi's saw themselves as superior to the Hutu's, and so to exterminate them was a way of ensuring the preservation of the superior race.

With the dawn of the colonial era, former independent African communities lost their political liberty with the division of the African continent into a patchwork that showed little regard for ethnic or linguistic boundaries. With this, the communities were squeezed into about 50 colonies marked out now by frontiers that took no account of fundamental interest. The Somali people were divided into four colonial systems: some were under the British, some under the Italians, some under the French and others under the Ethiopians. We also have some Hausas under the British rule in Nigeria and others under the French in Niger (Davidson, 1995). As a result, people who were bound by

ties of culture, language or even blood were divided by new territorial frontiers, which made them citizens of different states. This is one of the primary sources of tribalism in African Countries, tribes that have nothing in common were brought together to live as one.

Most often, the colonial government exploited the people and their natural resources. Only a very small share of profit was given to them. The colonies were used as sources for the raw materials and markets for the finished goods. This badly affected the native economy as this period of carnage went on for a very long time. The money generated by these colonial governments did not benefit the colonies. We still hear of African oil producing countries like Nigeria, taking their crude oil for refinement to western countries.

When the industrial revolution of the 19th C and 20th C brought increased exploitation of Africa due to the European demand for large quantities of raw materials, imperial overseers geared the economies of Africa towards exporting raw materials. Egypt produced cottons, Rwanda-Urundi was almost completely dedicated to growing coffee, and Upper Volta specialized in palm oil. Basing an entire nation's wealth on one commodity in this way would have debilitating effects later. This monocultures left national economies vulnerable to price swings, making economic planning difficult. This could be the cause of institutional hunger in Africa. These export crops were actually imposed on Africans; as a result they lost some of their foods meant for their subsistence. Many African countries are yet to trace their way back.

The colonial government was one in which the bureaucrat was absolutely king. In the absence of meaningful development among the legislative, executive and judiciary, the task of administration and adjudication, as well as the formation and implementation of policies were in the hands of the bureaucrats. The colonial administrators were elites, a chosen few who did not need to keep in touch with the lives and interests of the ordinary people, who were regarded as being at the lowest level of existence, incapable of rationality and insensitive to their environment (Gimba, 2006). Many African leaders now conceive themselves as chain minorities, thus, advancing individual rather than corporate economic and political development (Mark, 2008).

The true effects of colonialism are psychological. This is because domination by a foreign power creates a lasting sense of inferiority and subjugation that builds a barrier to growth and innovation. Many Africans have lost confidence in themselves and in their abilities. This has been extended to indigenous industries; whatever comes from the African is tagged 'inferior' by other Africans. This ranges from simple machines to clothes, furniture, bags, shoes, belts, etc. Indigenous industries now prefer to tag their products 'made in USA' or 'made in China or Taiwan', giving the impression that local products are not of desirable standards. Inferiority has turned our eyes to be 'outward looking' rather than 'inward looking'.

Colonialism has been described as a moral vice and a cultural bully of the Europeans, clearly elucidating the vices of the western culture in Africa. When the colonial masters came,

they gave us the impression that they were a superior race. In French colonies, through the principle of 'assimilation', they tried to stop the indigenous languages of colonies, which they considered inferior to the French Language. They looked forward to a day when all their colonies would speak one language, namely French. In British colonies, English was taught at schools. As such, many Africans have grown with the impression that their language is inferior (Gimba, 2006). Today many Africans have forgotten their languages, especially the young, and they feel that there is nothing wrong with that. It is in this regard that Senghor (1976) said that 'African misfortunes have been that our secret enemies while defending their values made us despise our own' (p.17).

Colonialism inflicted not only physical but also spiritual domination over Africans who began to see their traditional poetry, including freelancing with songs, dancing, and theatrical renditions as pagan. Gabriel Ajobodun once observed, 'our cultural values ranging from the sense of the sacred to respect for life and elders, respect for marriage institution, premarital sex, virginity, honest labour and communalism, are being submerged with the appreciation of the alien culture of materialism, nudity and hedonism' (Ajobodun 2001, p.15).

The schools instituted by the colonial masters where meant to teach colonial values. The subjects in schools were taught from racist standpoints. In history for example, the British colonial schools taught about British kings and Queens, while in areas like Geography, the four seasons of the autumn, the

summer and the winter were prominent topics. The African read all these, but could find in them no application for his continent. He learnt about realities that would imply a change of environment if he must be relevant. This accounts for the movement of highly skilled and qualified sons and daughters of Africa to countries abroad.

The Way Forward for Africa

It is true that the colonial government exploited the people of Africa and have contributed to the many crisis that now plague Africa, but is it enough to remember the past and then seat on its traumas? Africa must seek ways that would push her forward. Africa must stop crying over split milk and begin to raise her own cows. She must stop blaming the Europe for the evils of the past and begin to face the challenges of the present.

The African man and woman must have living hopes for their continent. Our leaders must burn with zeal for their 'father's house', a kind of zeal that gives birth to charismatic characters that can transform the darkness that lour over Africa into light. If we have lamented the evil of white colonialism and are today lamenting a new kind of colonialism by brother and sister Africans; if we rejoice over our independence and are today ruled by African dictators, if we blame the whites for the much orchestrated rape of Africa and are today realizing in the breed of African heads of state leaders who are committed to worse atrocities, then Africa has only taken a U-turn into a darker age than she has ever experienced.

The government of African countries need to provide a conducive and enabling atmosphere that can provoke in Africa the spirit of mental and physical revolution akin to the industrial revolution which made Europe the master of the civilized world; a conducive atmosphere that would challenge the sons and daughters of Africa in Diaspora who have been able to register the highest degree of academic feats in Europe and America to come and at least register some rudimentary technological and scientific breakthroughs at home. This forward movement of Africa is one in which every African must be involved; let Africans rally themselves into a formidable force defined by solidarity that would create a movement for the rise of Africa.

References

Sigmudo Feliz (1998). "Columbus on the Couch", *In The New Internationalist*, No. 226, Australia: York Press.

Woodward, R. L. (1985). *Central America: A Nation divided*, Oxford: Oxford University Press.

B W Hodder (1978). *Africa Today: A Short Introduction to African Affairs*, London, Methuen & CO Ltd.

V. C Ferkiss (1987). *'Colonialism'*, in The New Catholic Encyclopedia Vol 3, London: Chapman Ltd.

Fredrick Turner (1983). *Beyond Geography: The Western Spirit against the Wilderness*, Rutger University Press.

Alan Mountjoy & Clifford Embleton (1966). *Africa: A Geographical Study*, London: Hutchinson Educational.

Rodney Walter (1976). *How Europe Underdeveloped Africa*, London: Bogle 'Ouverture Publications.

Hans Koning (1991). *Columbus: His Enterprise, Exploding the Myth*, Monthly Review Press.

Davidson B. (1995). *Modern Africa: A Social and Political History*, London: Longman, 1995

Chinua Achebe (1985). *The trouble with Nigeria*, Taiwan: AI-united Industries & Shipping.

John Mark (2008). *Political Instability and Crisis in Africa: Problems and Prospects*, A Paper presented at the 12th NAMSPAN Conference held at St Augustine's Major Seminary, Jos.

Dikop Gimba (2006). Lecture Note on *African Traditional Society,* St Augustine's Major Seminary Jos.

Senghor L., (1976). *Prose and Poetry,* Trans. Keed & Wake, London: Heinemann.

Gabriel Ajobodun (2001). *Philosophy as a vital tool for social reconstruction in Nigeria, in NAPSSEC, Journal of African Philosophy*, Vol. 1, NAPSSEC publication Nig.

RACISM AND THE SOCIO-POLITICAL ECONOMY OF AFRICA

Introduction

The 19th century was the age of racism par excellence. At this time, so many theories and ideas about the nature of man were at cross-roads. This was when Charles Darwin produced his theory on the "Origin of Species by Natural Selection" in which he stated that from all variations of life found in the world, nature selects certain of them for survival while others are marked for extinction. Evolutionary thought is the alleged rationale for the many evils and harmful practices of the 19th and 20th centuries. Although Charles Darwin was not a racist, Berge (1973) maintains that Darwin's biological evolutionary theory was extended to social life, culminating in the white-European civilization. The stages of evolution were thought to be related to the innate genetic capabilities of various peoples of the world. By the mid 19th century, the intellectual climate was agog with this understanding and was spread through the writings of many philosophers, scientists, clergymen, statesmen, anthropologists and

sociologists like Joseph-Arthur, Compte de Gobineau, Houston Stuart Chamberlain, Adolf Hitler, among others.

Though this ideology led to the discovery of various streams like the refreshing waters of Sigmund Freud's psychoanalytical theories and techniques, which have enlarged our concept of the human person, it also led to dark waters as some of its effects are degraded morality, religion and traditional family and time-honored values of mankind. The Darwinian theory swept through Germany in the 20th century and sowed in it one of the most heinous manifestations of racism in human history, culminating in the crematoria of death camps in the 1940's in Europe. The Jews became the victims of genocide based on Adolf Hitler's theory of the master race and millions of the Jews were wiped off the face of the earth. These notwithstanding, the most widespread, enduring and virulent form of racism and the most expensive in terms of human suffering has been that which developed in Western Europe and its colonial extensions in Africa, Asia, Australia and the western hemisphere. However, this piece is concerned with an exposition of Africa's experience of racism and its consequences on the African nation.

Africa's Experience of Racism

Within the African context, we can understand racism as a system of thought that was developed in Europe which devalues the African people and makes her inferior to other races of the world. A quick glance at history reveals that when Africa had her first contact with the West, racism was one of the problems she had to grapple with. According

to Gimba (2007), at first, they thought that Africa had a civilization and as such treated them with respect and a sense of equality. Thus, Dagin (2007) asserts that the initial contact between Portugal and Africa was relatively free of racism and relatively peaceful and friendly. There are records of friendly correspondence between the King of Congo and Portugal and also the exchange of ambassadors. The King of Benin Kingdom is also known to have sent Jorgo and Antonio in 1514 as ambassadors to Portugal to dialogue on trade.

However, Berge (1973) avers that all these occurred before the European invasion of Africa through military incursions and sacking of cities and incessant demand for slaves for the Brazilian plantations. With the European invasion of Africa: the slave trade and colonization of Africans, the value and respect which they had for Africa began to die. Brazil soon became, with the West Indies and Southern English colonies one of the three major consumers of black slave laborers. This remained so until the mid 19^{th} century when slavery was abolished. In this case, racism became the rationalization for slavery and colonialism and also a means of splitting the colour lines and of deflecting attention for the central reality of class conflict of the "ancillary" problem of "race," for the sake of profit.

Following was the emergence of European racist theories. Limaeus (1758), an European Biologist, published a book titled "System of Nature", in which he said that all creatures were arranged by God in a great chain of hierarchy with man at the head. He further observed that human beings have their own hierarchy of being, with the black race closest to

the lowest animals. In the rank, the European race occupied highest position and was considered as the superior race.

Gobineau (1915) wrote a book titled "The Inequality of the Races." In this book, he also placed human beings on a hierarchy with Africa at the bottom. And for him only Europe had attained civilization while others have not. Hitler was known to have refused to shake hands with black athletes during an Olympic game on the grounds that they belong to the Aryan race.

Apart from the European racist theorists, there were some others who where against racism and tried to defend the humanity of the black race. Fredrick Douglass (1817-1895), an American, was one of those who stood for the black race. Consequent upon the racist theorists, he raised these questions, does the Negro create culture? Does he have culture like the other races? Is high culture synonymous with civilization? While addressing a group of American Ethnologists, he proved that by whatever test the black man is a human being, and that animals cannot create culture. He traced civilization back to Africa in ancient Egypt from where it spread to other parts of the world through cultural diffusion and borrowing, including Europe and America. Even though the arguments against racist theories were few, it was a good beginning for eventual liberation of the black race.

A Categorization of Racism in Africa

Racism in Africa could be categorized into two types: spontaneous, institutionalized racism.

Spontaneous Racism

The spontaneous kind of racism is still practiced in many parts of the world, especially in countries that have high rate of immigration. According to Victor and Wiley (1975), this was the situation in which many Africans found themselves, either as ex-slaves who decided to remain in Europe after the barn against slavery or Africans who traveled to Europe for studies or to pursue the good things of life usually associated with developed cities. Emerging from rural southern slavery where they worked in plantations after the First World War, they migrated from the rural areas to the cities, and to other parts of America. They faced discrimination in schools, jobs, housing, and almost in every other ramification of life. They generally attended to the lowest unskilled jobs and were isolated in miserable Ghettos in central cities. As a result of this discrimination, many blacks faced hardships in almost every sphere of life.

It is from this suffering minority African group that persons like Malcom X and Martin Luther King emerged. They fought aggressively against the oppression they were facing. They spent their efforts in building the confidence of the blacks by reminding them that the black race is beautiful and human as the white. They defined the white man's power structure and white racism as the cause of their oppression. They built movements that would survive the harrowing experiences of marches and jails. To this, the white authorities were not quiet, their police, tear gas and police dogs always stood against the black movements. Despite all odds, Victor and Wiley (1973) observed that the movement slowly and

painfully developed and flourished even in the barren soil of a hostile society. They appealed to justice and demanded on the conscience of the nation. A little light set the pace in 1954 when the Supreme Court ruled that segregating schools were unlawful. However, many whites dragged their feet and the Federal Government took no concrete action. The progress towards de-segregation began to pick up steam in the 1960's and major steps were taken in the 1970's.

Institutionalized Racism

According to the Pontifical Commission on Justice and Peace (1989), this is the kind of racism that is sanctioned by the constitution, which makes it constitutional as it is backed up by the law of the state. This is justified by the ideology of the superiority of persons from European stock over those of the African. This kind of racism is adequately expressed in the regime of apartheid or of "separate development".

Apartheid or "Separate Development"

Berge (1976) avers that if racism was an epidemic in the United States of America, in South Africa it was a way of life. Of all its contemporary multi-racial societies, South Africa was one of the complexly and rigidly stratified on the basis of race, and the one which was most ridden with conflict and other internal contradictions.

South Africa as a nation, is endowed with rich natural resources, ranging from diamond, gold, metals such

as platinum to fertile farmlands. She was invaded and colonized by the English and the Dutch in the 17th century after the discovery of gold and diamond in South Africa. Following independence from England, an uneasy power sharing between the two groups held sway until the 1940's, when the Afrikaner National Party was able to gain a strong majority. As a means of cementing their control over the economic and social system of South Africa, the national party invented the apartheid system of government, which emphasized territorial separation and police repression.

It was H. F. Verwoerd, the then Prime Minister of the ruling government that developed the policy of apartheid. The policy is simply: "the white and the non-white societies develop separately". In this regard countless laws brought about various limitations and restrictions, the towns were divided, with areas reserved for the white people and areas for non-white people in the Bantu Stan homelands. According to the African Encyclopaedia for Schools and Colleges (1974), in the areas belonging to the white people, the non-whites were not able to have their residence or own any property. As such, the white and the non-whites attended different schools, went to different hospital, in places where it was more serious, the whites travelled in different buses from that of the non-whites and even went into the same building through different doors. You dare not even talk about marriage between whites and blacks; in such conditions, one wouldn't doubt that the good jobs were reserved for the whites, while the blacks worked in mine, factories and as cleaners in the houses of whites, and to do this they traveled miles away from their homes to white settlements and would

have to travel back after the job. Berge (1973), describes the South Africa apartheid experience as one that has become next to the Nazi policy of genocide against the Jews, and represents the most extreme and systematic forms of racism that was ever practiced in the world.

The black lived in Soweto, South-West of Johannesburg. From here they went to Johannesburg every day to work. In Soweto, they lived in want and deprivation in contrast to the luxurious Johannesburg. In Soweto, life was hash and precarious, and the inhabitants not only suffered deprivation and dehumanization, but were also kept under constant and strict surveillance and the slightest sign of disturbance, whether real or imagined, was ruthlessly crushed. The result is that fear, violence and terror reigned. Vincent (1988), narrates that the nights were particularly frightening because not only does the law operate mostly then, but night provides cover for the other desperados to vent their frustration and anger on defenseless victims. Oswald Mtshali expressed the experience in Soweto in his poem *Nightfall in Soweto*.

Nightfall comes like
a dreaded disease
seeping through the pores
of a healthy body
and ravaging it beyond repair

a murder's hand
lurking in shadows,
clasping the dagger,
and striking down the helpless victim.

A Study in African Socio-Political Philosophy

I am a victim
I am the slaughtered
Every night in the streets
I am cornered by the fear
Gnawing at my timid heart;
In my helplessness I languished.

Man has ceased to be man
Man has become beast
Man has become prey.

I am a prey;
I am the quarry to be run down
By the marauding beast
Let loose by cruel nightfall
From his cage of death

Where is my refuge?
Where I am safe?
Not in my match box house
Where I barricade myself against nightfall.

I tremble at his crouching footsteps,
I quake at his deafening knock at the door.
"open up!" he barks like a rabid dog
Thirsty of my blood.

Nightfall! Nightfall!
You are my mortal enemy,
But why were ever created?
Why can't it be day time?
Daytime forever more?

It is from this group of the oppressed that Nelson Rolihahla Mandela was born. According to Egan (1994), he joined the Black Movement (ACN), and through it raised the general political consciousness of the people. Banning followed banning, but yet they were indefatigable in their pursuit of liberation. He made known to the marginalized South African that South Africa belongs to all who live in it, black and white, and that no government can justly claim authority unless it is based on the will of the people. A classic text in South African political and legal history reveals the spirit and dream of Mandella (cited by Egan 1994).

> I have fought against white domination, and I have fought against black domination. I have cherished the ideal of democratic and free society in which all persons live together in harmony and with equal opportunities. It is an ideal that I hope to live for and to achieve. But indeed be, it is an idea for which I am prepared to die (p. 175).

Almost 27 years after he and his 7 comrades convicted on 11th June 1964, he repeated these words before a crowd of many thousands. Today South Africa is liberated, and is one of the economically viable countries in Africa, characterized by freedom, and even if there are still traces of segregation, South Africa commands a battalion of hope.

The Consequences of Racial Discrimination on Africa

The effects of racial discrimination in Africa are as many as the causes. These effects range from psychological, social, educational to economic consequences. And these consequences are still painfully apparent.

Educationally, the outcomes are numerous, there is lower school participation rates for students in high racial environments. Illiteracy was a popular phenomenon, and the lack of literacy becomes a barrier to employment and further education, and so gifted and talented students wasted away and those who made effort were not recognized or developed. Individual's happiness and self-confidence were lost among school students who were subject to racist teachers; lower self-esteem took over, there were feelings of failure and withdrawal from others; the school climates were depressing; there was hardly friendship or co-operation between students because of the racial differences. This educational background would definitely not produce Africans who are educationally minded. If education is one of the basic paths to development, then it is obvious that these went a long way in affecting the different facets of the African life and development.

Frequent fights in playgrounds between students from different racial backgrounds formed groups in self-defence, and antagonism between staff of different racial groups brought about tension in learning and working environments. Self-hatred accompanied by neurotic symptoms of apathy,

anxiety, depression culminated in self destructive escapist reactions such as alcoholism, drug addiction, or even paranoid, schizophrenic and manic-depressive psychosis in extreme cases. Blacks in their ghettos turned their frustrations against themselves and this was encouraged by the state police in providing adequate protection. These experiences found home in South Africa during the immediate post-apartheid period, and even though they are greatly reduced, new expressions are not lacking.

To fit into the most powerful or dominant racial group, many Africans lost their cultural identity through the rejection of their own culture and parental values. Many students stopped speaking their languages for fear of ridicule. In so doing many lost touch with their cultural identity. In situations of extreme degradation as in South Africa, self-hatred emerged on the part of the oppressed' group, and the white man's definition of life became the Gospel truth.

One of the social consequences of racism is that it destroys group patriotism and threatens national unity. The emergence of two separate nations in one land can be an outcome as in the case of South Africa where the white and black nations emerged. Even among the blacks, there emerged two groups as well: those who were favored by the ruling whites and those who were not. Even after independence from the apartheid regime there were still animosities between them.

Economically, racism is very expensive. The millions of dollars lost in race riots in South Africa and in Europe, the maintenance of separate physical facilities, the legal costs involved, welfare and employment payments and losses must

be contended with. This money could have been used for the development of the nation. Racism is also deleterious to productivity, in that a large part of the national work force remains un-utilized maximally because of racial prejudice.

Racism gives the whole country a black-eye in relation to the international community, as when South Africa was universally condemned and deprived participation in world events and trade for many years, this is because where there is no justice and peace, violence and wars easily break-out, and relations with other nations is disturbed. Amidst all these, it is still the poor who are discriminated that suffer. The Lords have only little to lose.

Conclusion

In Europe and America, it can be said that a huge progress has been made as regards the abolition of racism. However, there remains major issues to be won in battle for black equality. Many of the racial terms have been clothed in new garments so that they are hardly identified. As such, the black revolution that began years ago still strives on. Blacks are still discriminated against, at the airport, in train stations, at their places of work, and even in churches. No one doubts all human beings are not of the same colour and capability, but this does not provide enough ground for any form of social and cultural discrimination in basic personal rights on the grounds of sex, race, colour, language, religion and social conditions (Gaudium et Spes 1990). When Pope Paul VI (1978) was speaking to the Diplomatic Corps he said:

For those who believe in God, all human beings, even the least privileged are sons and daughters of the universal father who created them in the image and guides their destinies with thoughtful love. The Fatherhood of God means brotherhood among men: this is a strong point of Christian universalism, a common point, too with other great religions and axiom of the highest human wisdom of all times, that which involves the promotion of man's dignity (p. 178).

Racism, of any form, is an abuse of human dignity. From the scientific perspective, all human persons are descended from one same stock, homo sapiens. Philosophical studies have revealed that reality is one, and that the present plurality is only temporal and would culminate in the one at the consummation of things. This is also true of the findings of major religions.

References

Berge, P. L. V. (1973). *The New Encyclopaedia Britannica*, Vol. 15. Toronto: William Benton Publishers.

Gimba, B. (2007). *Note on Traditional African Societies.* St Augustine's Major Seminary Jos. Department of Theology.

Dagin, S. (2007). *Note on West African Christianity.* St Augustine's Major Seminary Jos. Department of Theology.

Victor, J. and Wiley, J. (1975). *Sociology: A Critical Approach to power, change and conflict.* USA: Basic Books.

The Pontifical Commission on Justice and Peace (1989). *The Church and Racism: Towards a fraternal society.* USA: Daughters of St Paul.

Berge, P. L. V. (1995). *Race and Racism in South Africa.* In A.Betteille (Ed.)., In *Social Inequality* (pp. 310-320). Britain: Penguin.

African Encyclopedia for Schools and Colleges (1974). *Apartheid.* In Oxford: Oxford University Press.

Vincent, K. S. (Ed.) (1998). *A selection of African poetry.* England: Longman.

Mtshali, O. (1998). In K. S. Vincent (Ed.). *A selection of African poetry.* England: Longman.

Egan, A. (1994). *The Making of a President, 1994: Nelson Mandela.* In the Month.173-174

Gaudium et Spes (1999). In A. Flannery (Ed.). *Second Vatican Council Document* (pp. 903-1001). Ogun: The Ambassador.

Paul VI (1978). *Discourse to the Diplomatic Corps.* January 14.

UNESCO (1973). *Le Racisme Devant La Science. UNESCO Paris. 1.* 369.

Gobineau, A. (1915). *The inequality of human race.* London: William Heinemann.

Linnaeus, C. (1758). *System of nature.* Stockholm: Laurentius Salvius.

www.ingramcontent.com/pod-product-compliance
Lightning Source LLC
Chambersburg PA
CBHW030936180526
45163CB00002B/595